CERAMIC ARTISTS

ON CREATIVE PROCESSES

Acknowledgements

Thanks to all the ceramicists who appear in this book for their generosity and effort. And also for their enthusiasm and dedication to this project. Talking about personal work or explaining something as intangible and ethereal as creativity and the processes that lead to the formulation of ideas is not easy.

HOW IDEAS
ARE BORN

CERAMIC ARTISTS
ON CREATIVE PROCESSES

Teresa de la Cal - Miguel Ángel P. Arteaga

 HOAKI

C/ Ausiàs March, 128
08013 Barcelona, Spain
T. 0034 935 952 283
F. 0034 932 654 883
info@hoaki.com
www.hoaki.com
🔘 hoakibooks

Series: How Ideas Are Born.
Ceramic Artists on Creative Processes

ISBN: 978-84-19220-48-6

© to the publication, 2024, Hoaki Books, S.L.
© to the text, Teresa de la Cal and Miguel Ángel P. Arteaga
© to the images and personal texts, their authors

Authors: Teresa de la Cal and Miguel Ángel P. Arteaga
Art director: Miguel Ángel P. Arteaga
Cover image: Kaori Kurihara
Layout: Batidora de Ideas
Translation: Kevin Krell
Publication coordinator: Ricardo Rendón

DL: B 16605-2023
Printed in China

/

The secret

Building castles in the sand, which involves defensive walls and turrets and could be construed as an initiation into the world of war, is one of the experiences of childhood that remains fixed in our memory.

For this reason, I vividly recall my father, when I was six and my brother three, and a bucket in the shape of a crenellated tower, a matching shovel and rake, and small coloured moulds.

We choose the place carefully, smooth it out, find somewhere close by as a source of moist sand, never dry, never too wet. We fill the bucket to the top, smack it lightly with the shovel so that it fills correctly and to get rid of the excess water. Then we lift it, upending it quickly in the air, and set it with a sharp blow on the ground. If we're lucky, if we've completed all the steps with the requisite expertise, the first tower will materialise impressively before our eyes. All that is required are planning, knowledge of the basic technique and practice.

After this promising start, everything else might seem less exciting, mere repetition. Two towers, three towers, four towers, and simple thick defensive walls placed between them. The infinite sea, dazzling blue, a stretch of smooth sand separating it from a small artificial rise atop of which our fortress sits. But the best is yet to come. After a job well done, after the collective engineering effort, comes a break — the feeling of pride in a piece of work that will surely be admired by anyone passing by.

And then, like a sudden and unprovoked slap in the face, comes what is perhaps the first and most important message in our life: the discovery of the destructive power of nature, or what amounts to the same, the inability of human beings to control it.

The first wave crashes and washes everything away.

From that moment on we build something to be destroyed, and it's not the same. Each time higher walls, canals, moats, containment dykes...

Brute force appears, the struggle against the inevitable while sensitivity, magic and the love of perfection vanish. The same scene, repeated a billion times since the dawn of history. A rite of passage between parents, their children, and the sea.

Every summer the same dance is repeated, choreographed, somewhat robotic, of tiny masons that oversee the work. Thousands of works along thousands of coasts. In our case a master and his two apprentices as specialist castle labourers, working without rest, regardless of the weather and oblivious to the mocking glances of passers-by.

Tower, tower, wall, tower, tower, wall, moat.

The summers almost merge with one another in our memory. Time goes by very quickly, and we always discover that in the end it always happens as planned.

Maybe I'm ten now, and we've built fifty castles so far, all the same and yet all completely different.

Suddenly my father looks at me. He remains thoughtful for a few seconds that feel like an eternity. Now is the time to learn the secret! He steps over to the shore, fills his big hands with sand mixed with a lot of water. He squeezes his hands tightly and some of the water falls. He steps over to the tower we've just built, stands above it and little by little, lets what he's holding in his hands spill out.

Little heaps of wet sand pile one on top of the other, like controlled explosions they accumulate overlapping from highest to lowest. Intertwined slurry braids randomly fall, are destroyed and created again.

Before the astonished gaze of two boys, we discover the secret of Gaudí and his Sagrada Familia, of nature, fractals, order and chaos, the origin of the universe, learned by observing a simple movement of the hands.

Perhaps this is the source of my love of architecture, of observing the space around me, the search for creative solutions, the love of what is fleeting, of working with my hands, of imperfection and improvisation.

Because there is no child who doesn't get excited about building in the sand, shaping with play dough, with clay or their own food. It's the pure pleasure of creating, of building invented worlds.

/

Miguel Ángel P. Arteaga

/

Art, earth, water, air, fire

From a combination of the hands, clay, the chemistry of the materials and fire, ceramics emerges in a process filled with surprise, uncertainty and magic. Achieving it requires deep knowledge of technique and taking into account many factors.

The interest that a piece of pottery arouses focuses usually on knowing how it was made: how it was shaped, the glaze or engobe used, the temperature at which it was fired, in what atmosphere, with what kind of kiln... valuing mainly the artistry and good workmanship needed to make a quality ceramic piece.

In this book, keeping in mind high-quality work and the alchemy it requires, our intention is to shine a spotlight on the creativity of ceramicists who share with us their most personal work, capable of moving us emotionally, surprising us, and making us think.

The creative process of any artist, whether a painter, dancer, writer, musician, illustrator or sculptor, always fascinates us. What makes them so special? What inspires them? What moves them? How do they do it?

Behind every work of art there is always a journey filled with passion, energy, at times uncertainty, fear and clarity.

Twenty-seven ceramic artists from around the world tell us in their own words and with great generosity what led them to create these pieces and how they came up with them. They allow us to move in a little closer, to appreciate the details. To learn!

These artists embody exploration, risk, versatility. They shape light, reveal transparencies, rediscover millennial traditions, translate invisible colours, reinvent vanishing points, impossible perspectives. They whisper between shadows, make thought light, recite poetry where the most ordinary unfolds, shift limits, eliminate borders, narrate universes, rebel, dive deep into memory, penetrate silence with the most subtle elegance.

A ceramicist's mind and hands create an object where art, earth, water, air and fire converge. From the moment we knead it, clay requires careful attention. The wonderful transformation it undergoes requires calm. To understand and appreciate ceramics, we have to grant it the unhurried pace it demands of us.

/
Teresa de la Cal

Monsieur Cailloux

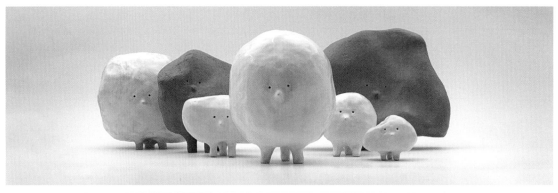

Photography: Diane Chandaras.

An explorer interested in discovery, Monsieur Cailloux travels through space in his extraterrestrial vessel in search of new life forms. After years of cosmic wandering, from deserted stars to arid systems, he lands on the planet MRCX and discovers a form of life: a tribe of Cailloux.

'My work is more than anything a story: of the tribe of *Cailloux* discovered on the planet MRCX during my space travels. On my Instagram page (@monsieur_ cailloux_), I tell the story of my encounter with these poetic beings from a deceptively scientific angle, using animated films.

For each discovery, I number and indicate its weight, size, approximate age and the place it was last seen. When somebody adopts a *Cailloux*, they receive a map of the planet MRCX and a document that certifies the work, signed by me, in which they find all the information about this unique being. Through this metaphor of the discovery of another world, I present my own exploration of ceramics.

My pieces have been adopted throughout the world, which for me brings the highest satisfaction. I love the idea that people from different cultures can be touched by my specimens to the point that they want to adopt one. Anyone who looks at these *Cailloux* is transported instantaneously to their own planet, to their own imagination, which is no longer mine.'

'My work as a ceramicist is sensitive and deceptively naive. I want to bring poetry and imagination to our daily lives, to continue making up stories and dreaming.'

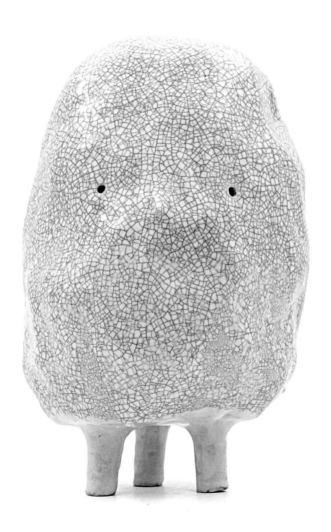

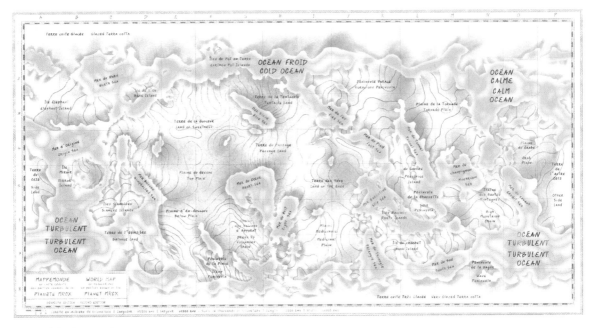

Map of the planet MRCX.

'To be a good ceramicist you must be patient and know how to let yourself go. The shaping, drying, glazing and firing take time and can be filled with surprises. When you start to explore clay, you discover another sense of time, far from our modern world predicated on speed. Working with clay means agreeing to proceed at the rhythm of this living material, to play following the rules that it imposes and never thinking that you're stronger than it. This is what attracts me about this art: exploring my own world with a material intrinsically tied to what surrounds us.'

'I try to experience simple emotions when I'm in a creative process. To achieve it, I consciously try to rediscover the imagination, the way I saw the world when I was a child. I find a guileless pleasure in immersing myself in another reality, in activating an imagination that allows me to escape for a moment in the presence of an idea or work of art. I'm convinced that if I can access the poetry of the child we have within us, then I've hit on a universal truth that shakes up our adult vision and touches us deeply.

I don't think we can have an idea by ourselves, because we need to be nurtured to be born. It comes from an unconscious process of integration of what surrounds us. It touches us and appears through the prism of our own story, our desires and our imagination. It's our sensitivity and our vision of the world that allows us to transcribe this material in a unique artistic language. Accepting this awareness and assuming the risk of revealing it also form part of the creative process.

If an idea triggers a primitive happiness in me, I'll then have the energy to make it into a reality. When I encounter an idea that's worth it, it's also because I see it as being relevant in the present context, as if it arrived at just the right time, as if it were aligned with everything that surrounds it.'

'I love creative blocks, because it's a time to question one's own work, to shake it up to find new solutions. Accepting the block means accepting going out of one's comfort zone and taking a path that's different from the one you imagined at first. They allow me to explore new creative horizons which, in turn, lead me to new challenges and so on.'

'I was born in Nantes, in a family open to the world where I could navigate between popular culture and contemporary art. When I was very young I fell in love with science-fiction films and primitive African art.

I've also lived in Oslo and currently live in Paris, places where design and art occupy an important place. My sources of inspiration are numerous. I'm not biased about what is tasteful or not. I seek only to be moved, without worrying about the focus or medium.

To come up with ideas, I like to be in a peaceful place listening to the sound of my favourite records to let my mind wander and imagine without being bothered by other distractions. Then I use several notebooks to take notes, draw my next pieces and imagine the story of the tribe of *Cailloux* and its environment: planet MRCX.

My work is based on imperfection. I try to make visible the humanity hidden within us, focusing on the inconsistencies and defects of handmade work. Which is to say, mistakes are for me a source of happiness.'

Roger Coll

Photography: Yurian Quintanas.

Photography: Joan Santaugini.

'Working with ceramics requires in my case, and for the kind of pieces I create, an organised, methodical and routine process, but with the desire that the final result seems a little bit the opposite. You could say that the pieces in a way need to flow and seem happy.'

'Something that defines me, that I think is important, is having grown up somewhere between the country (where I spent most of my childhood, since my family both on my father and mother's side were Catalan peasant farmers) and the city (Badalona and Barcelona, only six kilometres from where my grandparents lived). I think this feeling of always being halfway between two worlds defines me quite well and is an important factor in understanding why I work with clay and with colours, textures, etc. the way I do.

After studying architecture, sculpture and ceramics and working for several years in a surveyor's office in Barcelona, I set up my first ceramic studio and workshop. In 2014, I moved to Vic, where I live and work.

I like to think we all have our own artistic language, or at least we try to find it. In my case every sculpture I make is part of my own language that I'm developing. Each sculpture is like a word that helps to define it. If I was good with words or rhythm, I would be a writer or a musician, but I'm not. So I use another medium to express myself. In this sense, if the pieces are like the words of my own language, then terms such as scale, texture and colour are elements that help set the tone and transmit the message. That said, my use of colour isn't rational but intuitive. Sometimes I feel that a specific work needs this colour and not another. But I can't explain why.'

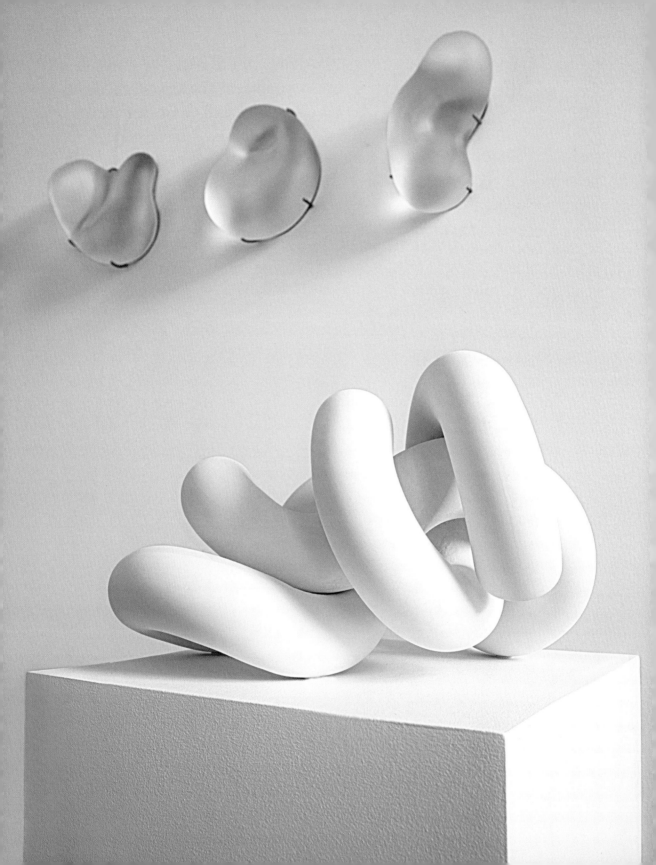

'I think that studio work, creativity, unless you're a genius, is based on tests, mistakes and hours of work. Ideas come from interrogating our own obsessions and interests. In my case I'm fascinated by things like repetition. Being able to start from a simple and humble element and through its repetition create a more complex form and concept.'

'When I was doing an internship in a surveyor's office, part of my job was to visit the works. There I always found scraps of the construction materials used which today form part of my collection, my treasures. Always human-made materials: iron, foam, plastics, etc. Anything that strikes me as sculptural.

When I think that I can't imagine the forms abstractly and I'm not interested in the previous digital design. I enjoy the process of shaping ideas directly with my hands, manipulating the material and making choices about what I see at the moment.

If you work with ceramics, mistakes are implicit in the name, so you have to learn to manage them. Play has a very important role. As I said before, the pieces don't come from a previous design, something that would transform their construction into something boring consisting of reproducing what's already on paper. What I enjoy is making decisions as the piece unfolds. Always following an agenda of order, routine and technical rigour to avoid problems, cracks, etc. in the pieces but with the freedom to decide in the moment. Partly not knowing exactly where I'm going is crucial for me.

I try to have interests outside of sculptural ceramics. Lately, when I'm burned out, I take a break for a couple of days or more and take time to paint. It helps me to return to work again with renewed energy.'

Photography: Officine Saffi in Collect London. Courtesy of the artists and Officine Saffi.

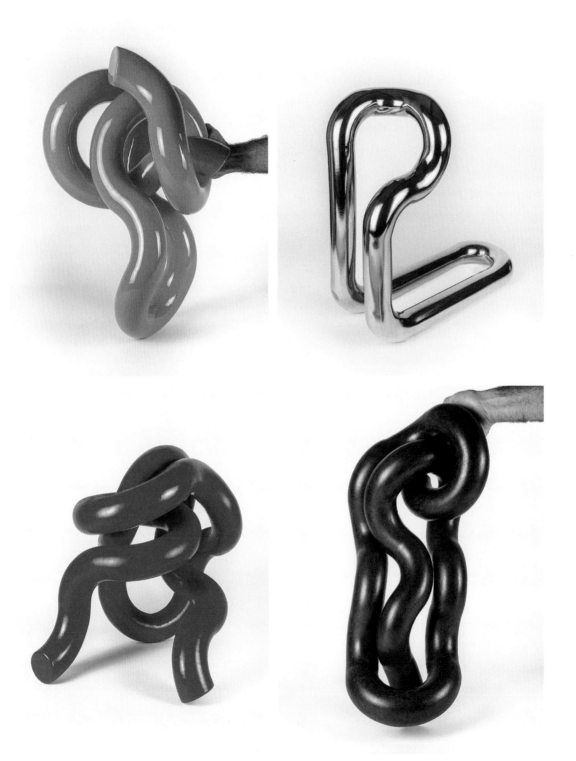

Photography: Joan Santaugini.

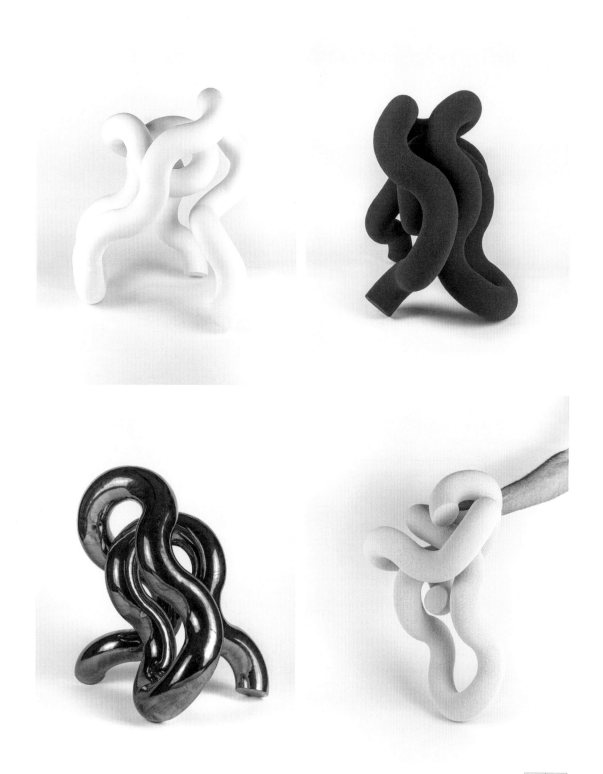

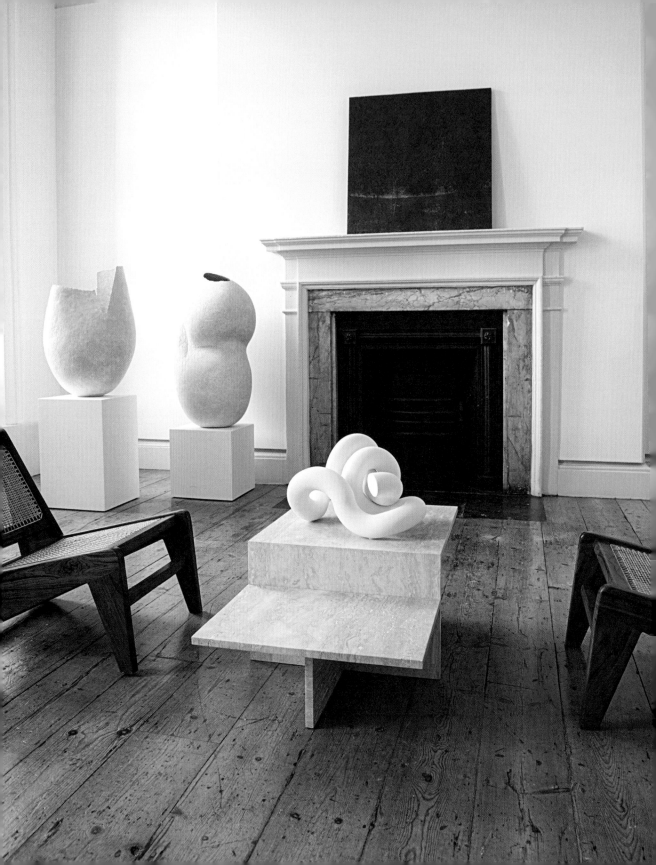

'I think that because ceramics allows for so many options, finishes, languages and different techniques, there probably isn't a single secret to being a good ceramicist. Mine can be summed up as the hours put in.'

'The transition from working in an architecture studio to my own ceramics workshop is a nearly ten-year process from those first days with ceramics, because it really took me a long time to make that decision. During this lengthy period, I studied sculpture in an art and design school in Barcelona. After a few years going twice a week to that first private ceramics school, I thought about enrolling in an accredited art and design school to study ceramics part time from Monday to Friday.

While taking the admissions exam, I realised that what I was really interested in was sculpture. So that's what I pursued, sculpture. Over the years I also studied ceramics and lost some of my interest in architecture as a profession, because the only thing that I could think about all the time was sculpture and ceramics. And it really made me happy. Later, I was lucky enough to obtain an internship to go to Finland for a few months and work as a sculptor's assistant. It was then when I decided to quit my job and set up my own studio once I got back from Helsinki.

Architecture has had a huge influence on my work. Not only because when you work in architecture you have to think about the materials, their characteristics, how they behave, etc., but also the constructive part.

Most of my sculptures are "built", not shaped or sculpted. In my work I use segments which I gradually join to create the final form. In the same way bricks are used to build I wall I suppose. The use of a repeated element to create something unique still fascinates me. This element of repetition is very important in my work. If I hadn't studied architecture my work would be completely different.'

Photography: Louise Reyé.

Monika Debus

'I'm more interested in the imaginary space I can create than what is real. In the best of cases, a piece opens an entire space of possibilities, associations and free emotions for the observer.'

'My work combines clay and its plastic qualities with abstract and free painting. With my pot-sculptures, sculptures and mural work, I try to explore the limits and, even more, to create connections between ceramics and sculpture, painting, tradition and modernity, between art and craftsmanship, art and the observer, and also between feeling and understanding, simplicity and complexity...

Clay and engobe are the simplest mediums to work in ceramics. Complicated things are foreign to me. I can't deny an amazing experience, but expressively it isn't my goal, just as for me the supposed docility of clay and the temptation to treat it innocently aren't my objective. I'm inspired by what I encounter every day, people, music, nature... but also by my daily work with the material.

Firing the salt changes the surface from clear to dark and gives the work a soft depth. Chance plays a deliberate role in this. I think it's exciting to use this old firing method from the Westerwald to obtain a new and modern appearance. All the pieces are made with coloured stoneware firing clay and painted with porcelain engobes. They're salt fired to 1140 °C in a reduction atmosphere.'

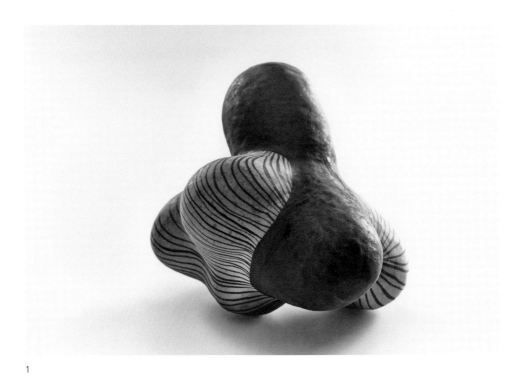

1

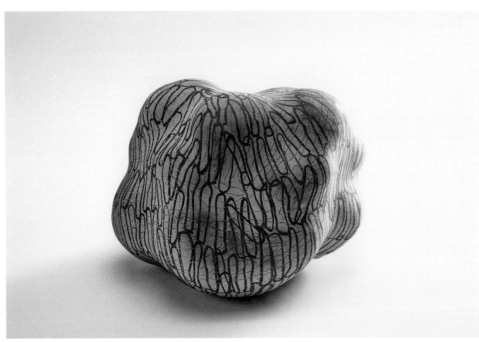

2

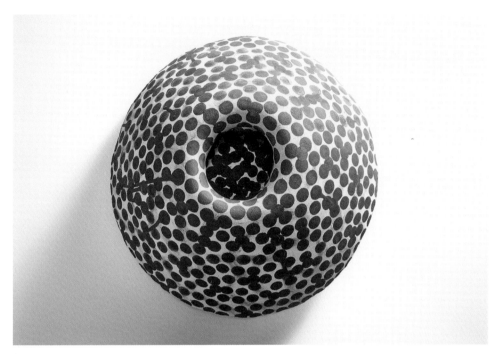

3

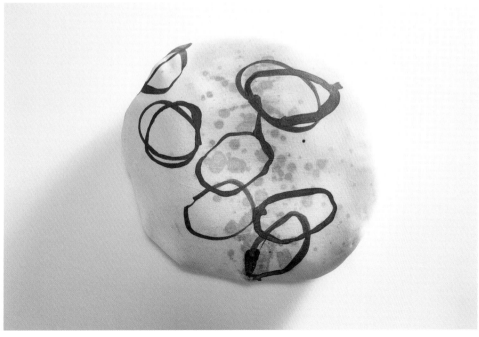

4

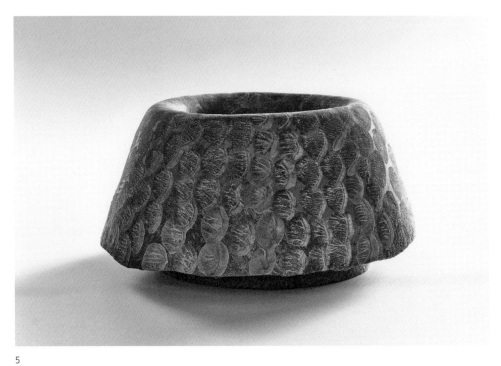

5

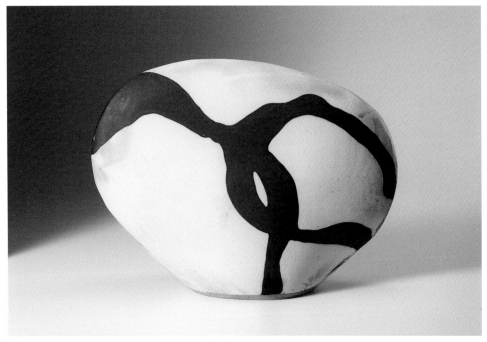

6

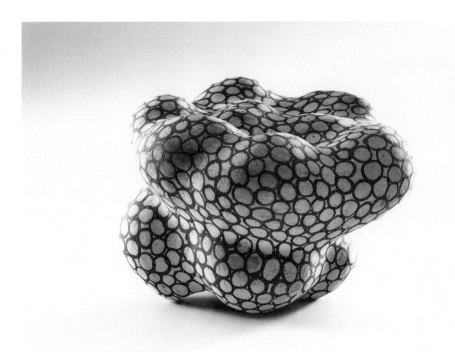

7

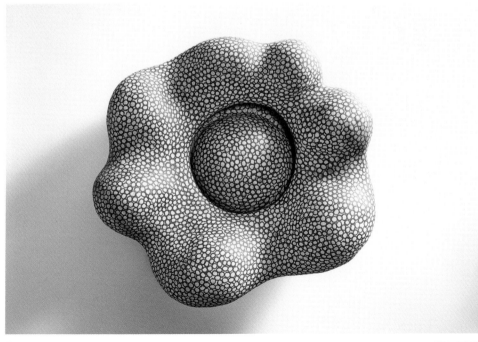

8

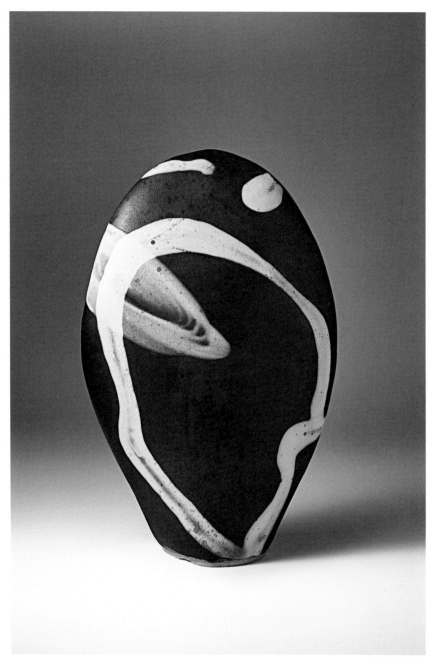

'Being wrong is a very important resource in my work. In the first place, to admit that one can make a mistake and secondly, and more importantly, because it opens up new spaces, new possibilities. Chance is important.'

'I can't explain my creative process. It's an interaction of things that you see, things that you hear or read, experiences you have, choices you make. A walk through the woods, a conversation, music, the sports you play. Whatever it is. All my activities imply a certain way of being, physically and mentally, and this is reflected in my work.

Ideas come from all the above and also from working with the material (hardly any material is as direct as clay). You work from a visceral feeling and, to a certain extent, also at a critical distance from your own work. At least that's what I try to do.'

1 *All about moving*, 2021.
2 *Underwaterlove*, 2022.
3 *Mural*, 2022.
4 *Mural*, 2022.
5. *Moss,* 2022.
6. *Vesselform*, 2018.
7. *Blue form*, 2022.
8. *Small form*, 2016. painted
9. *Vesselform*, 2021. painted

Godeleine de Rosamel

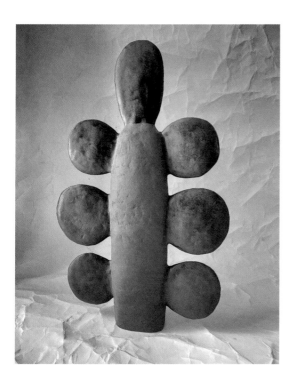

'I'm a French artist based in Los Angeles, California. I was born in Lille, in 1968, and my passion for the arts began when I was a child. I used to spend hours drawing and taking my first ceramics classes at the Musee des Arts Dècoratifs in Paris. In 1986, I attended the École de Recherche Graphique (ERG) in Brussels, Belgium, and then began a career as a children's book illustrator.

I moved to Los Angeles in 2001, and it was there where my focus returned seriously to ceramics. In 2014, I showed my ceramic work for the first time in a group exhibition at the gallery Giant Robot 2 in Los Angeles.

I like that my work allows me to play first, to be the original creator of imaginary life forms, and then to represent the process of evolution through which they struggle to adapt and perfect themselves undergo incremental changes, while I experiment constantly with different forms and glazes.

After several years of seeing my animals grow and evolve, I realised they needed their own plant and tree biotope to develop and mature in relation to them. Creating the plants ended up being as complicated as creating the animals. But it was then that I realised how much living in California has inspired me, with its beautiful deserts and incredibly visual and hardy vegetation. This development in my work continues and increases at the same time my interest in natural history, evolution and the wonders of nature in general.'

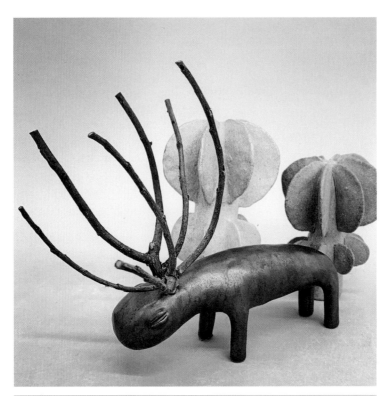
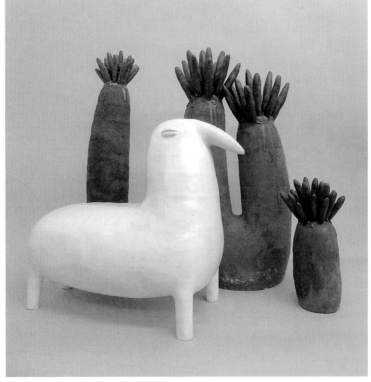

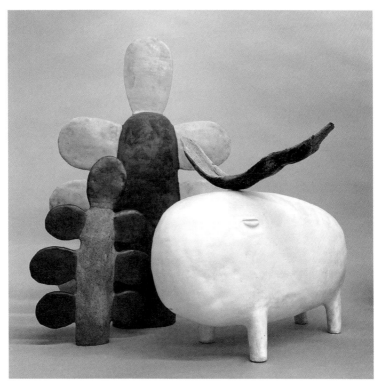

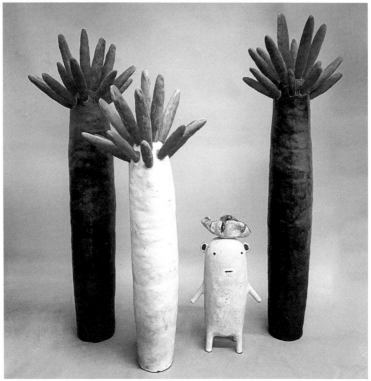

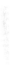

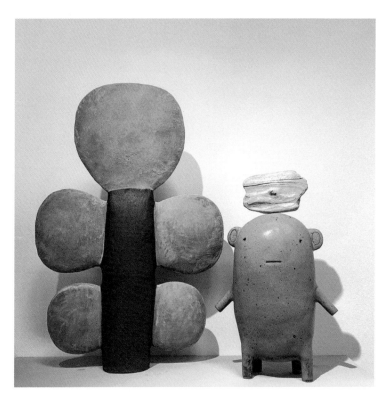

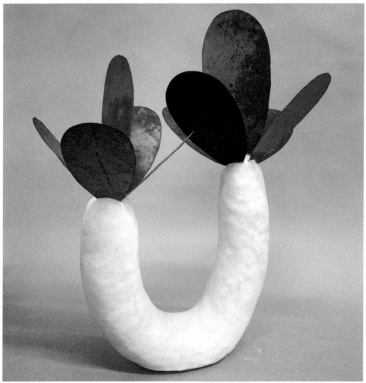

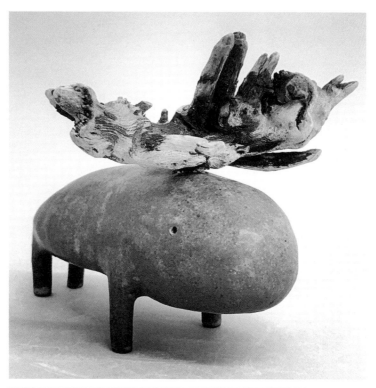

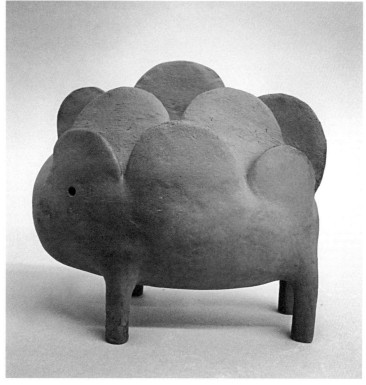

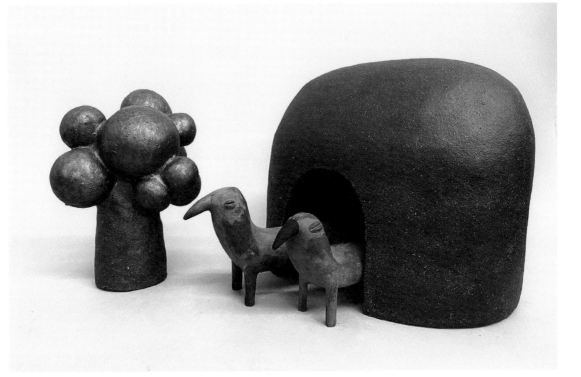

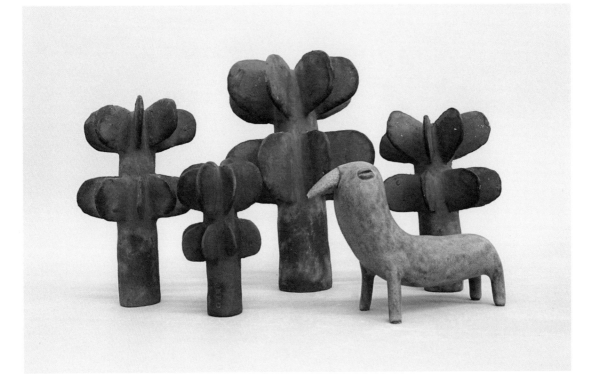

'I've always been attracted to so-called "low technology" and the fact that you can create beautiful and meaningful art using very simple materials. The first civilisations produced incredible art with clay and pigments.'

'While I incorporate modern techniques into my work, the process of starting each piece with my hands and clay makes me feel connected to a very old human tradition. I feel obligated to create pieces which in my mind are faithful to human beings' concern for other living things. By making my sculptures out of clay and incorporating different materials (mainly wood), I know that I'm still experiencing the same feelings of surprise, mystery and reverence produced by this unifying art since the origins of humanity.

When I work in my studio, often I find myself reflecting on the continuous loss of actual species that we're witnessing, wishing the plants and animals that surround us were better adapted to maintaining their position in a world dominated by humans. In my work, I want to create an imagined world that is also familiar and consistent, as if I were the first human to discover it. But I know that if I could repopulate the planet, it would be a utopia without humans where politics, gender and suffering didn't exist. Handsome well-nourished creatures would roam freely through the forest and sleep undisturbed beneath the trees.'

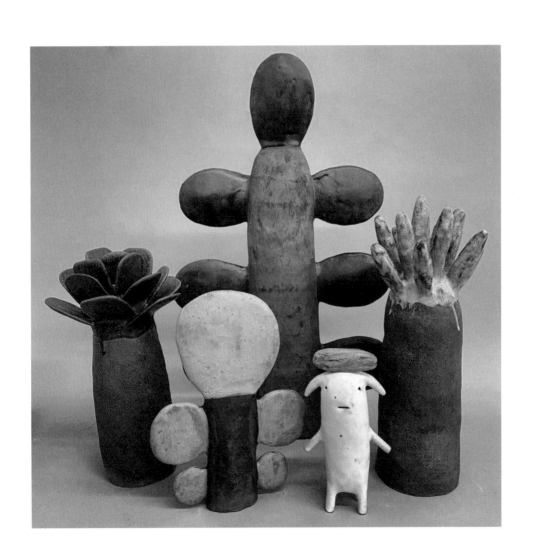

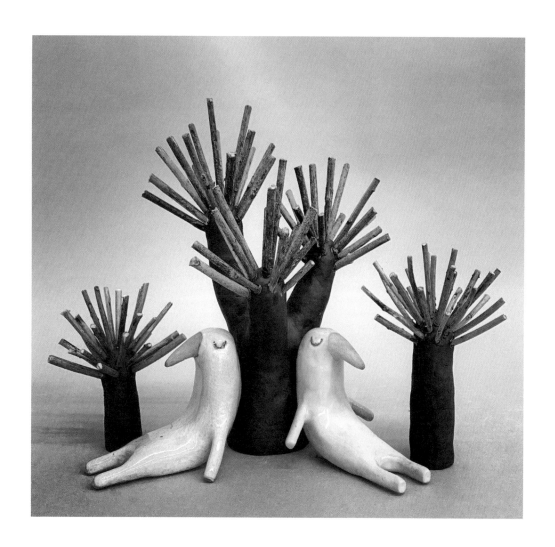

Nathalie Doyen

Photography: Bénédicte Goethals.

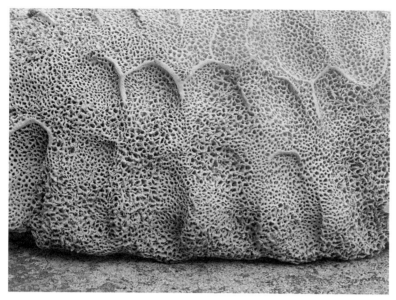
Photography: Bénédicte Goethals.

'There's a widespread cliché about the eccentric artist that proclaims his or her subjectivity. As far as I'm concerned, I don't sign my work. I try to listen to what emerges through me without always being able to explain it.

With experience, you can start to talk about artistic intelligence. It's not a matter of being extremely gifted or not. The gift doesn't fall out of the sky. I've worked a lot, intensely. Can we call it passion? I'd say it's a trade, which is the love of art.'

'Shaping means being available for the present moment, for intuition, for the ineffable, for the event, for the dialogue with the clay, for the resonance of the unconscious.'

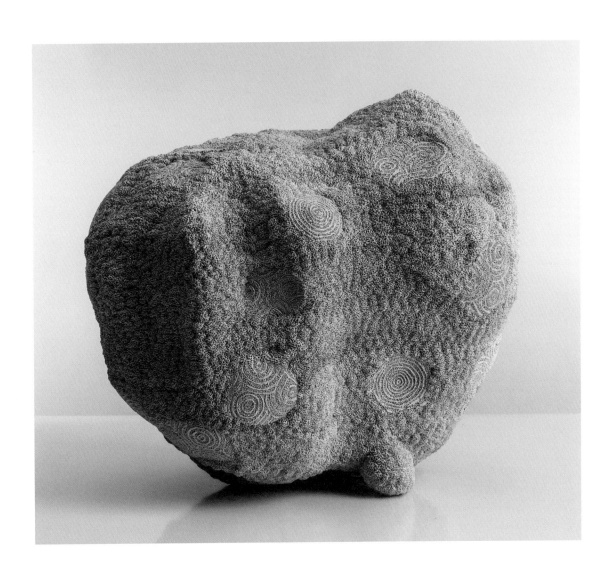

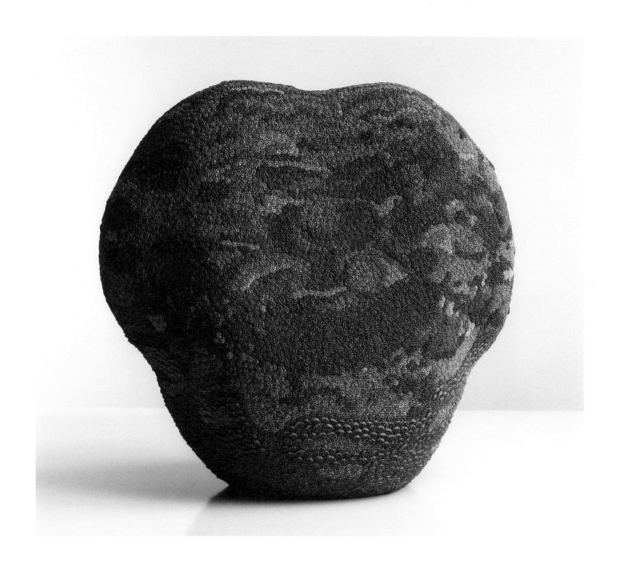

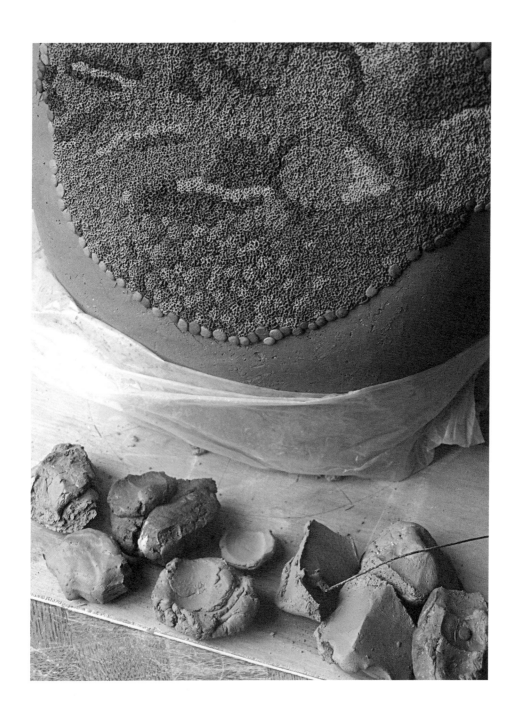

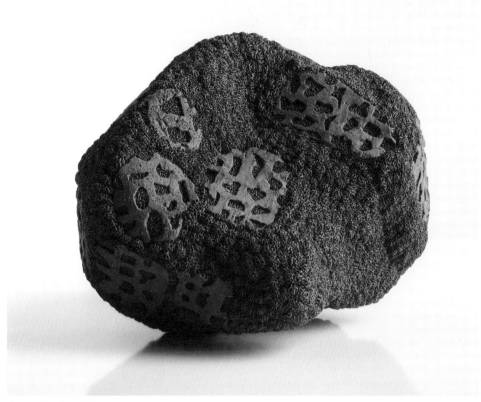

Photography: Photo Gilman.

'The pieces and installations I've created represent a lifelong project.'

'Spending days away from consumer society, creating alone. I try to touch on the essential even when the people in charge have labelled us as non-essential. To disembark onto an island of peace, even in times of war, is a small drop for humanity.

I feel like I'm always searching. A background is continuously woven with, depending on the project, modulations of space, dimension, luminosity, textures and colours. Sometimes I work "outside of time, outside of space", while other signals appear which lead to a specific order, a precise place, a theme. I borrow a bit of clay from the earth to offer wonders.'

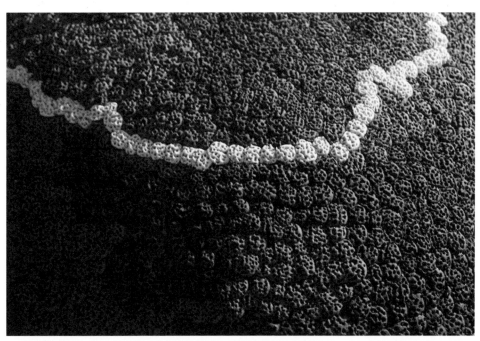

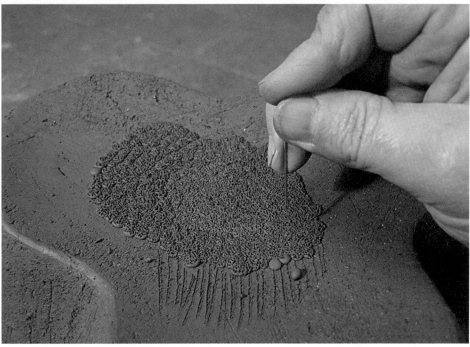

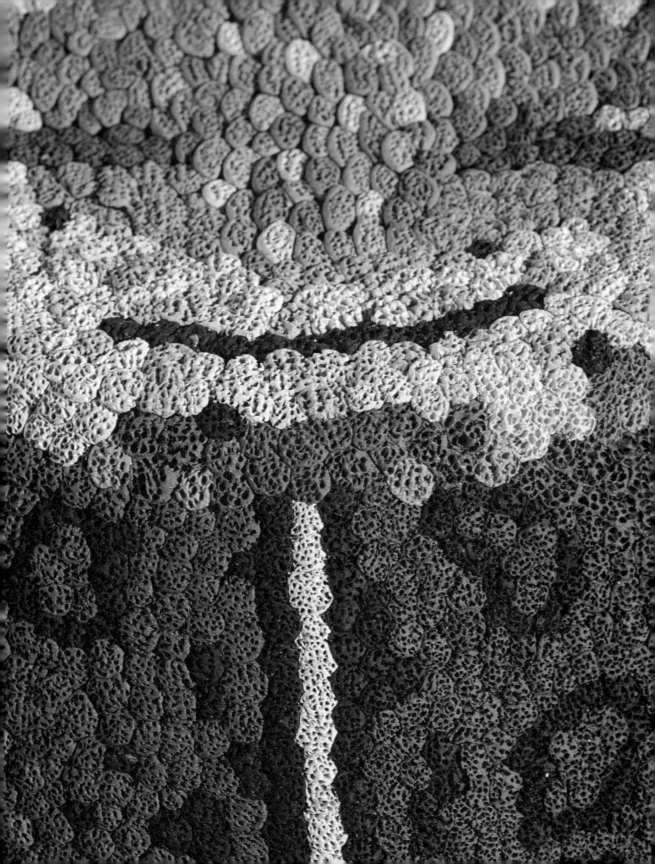

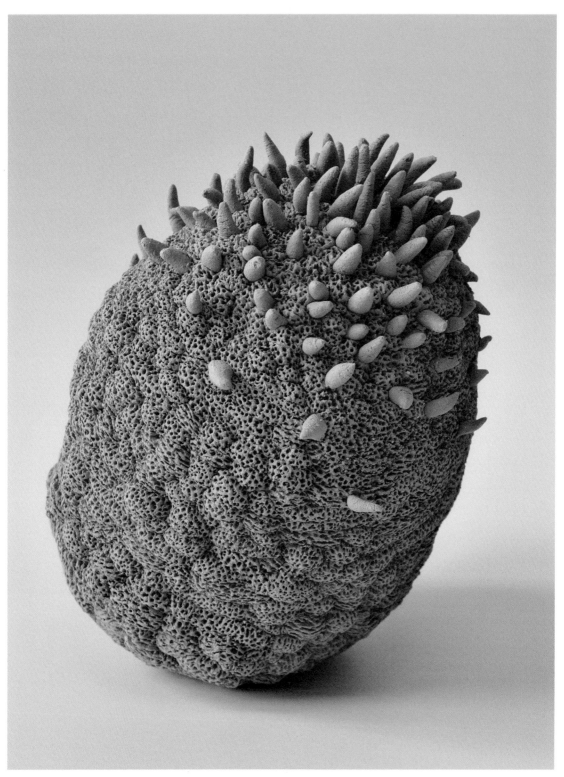

Photography: Tiziana Del Vecchio.

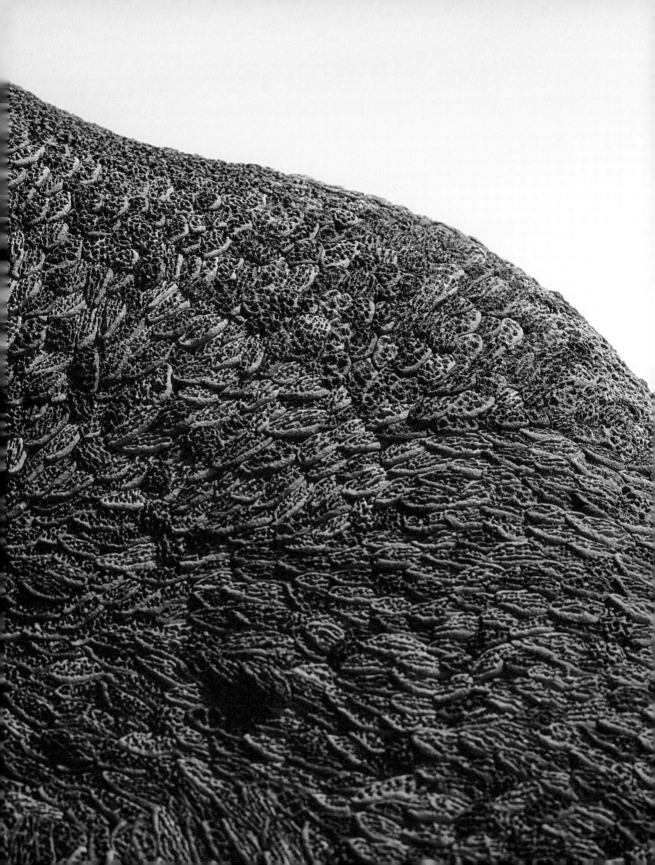

Ngozi-Omeje Ezema

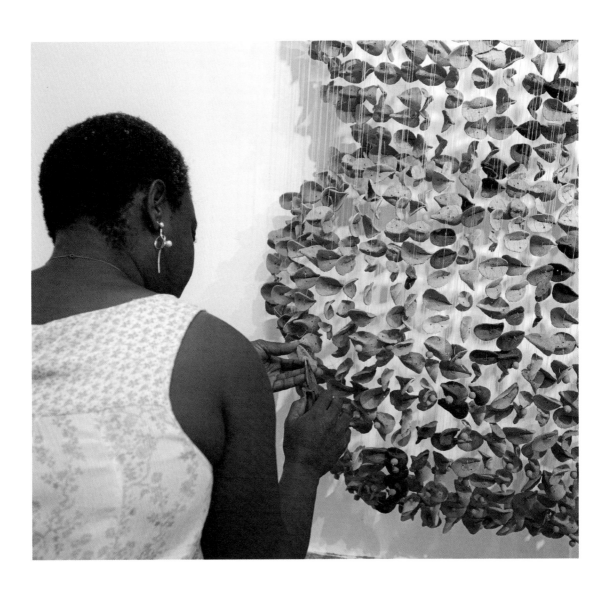

'I was born in 1979, into the Lazarus Omeje family in Nsukka, Enugu state, Nigeria. My parents and my siblings encouraged me to devote myself to being creative. My father was a welder who built metal designer tables and chairs, and my mother a seamstress. They were artists in their own way.

My father's area (building) shares features with fine arts and applied arts, so he was able to recognise the innate creative abilities of his children. Still, I'm the only one who chose fine arts as their career path, except for my older brother who recently took up graphic design after giving it up when he was young. That said, almost everyone in my family is good at illustration while others work as critics.

Basically, I started with the rudiments of ceramics, using techniques such as roughing, pinching and curling to create pots, jars and other forms, as well as throwing on the potter's wheel.

I continued with these basic techniques until an accident occurred in 2006. I lost all the pitchers for an exhibition. Only the lids were exhibited along with other types of art (painting, sculpture, textile, etc.). As a result, they referred to me as "Onye ite abughi ahia" (a potter without a trade). Reflecting on the phrase during the exhibition became an inflection point in my career. To overcome limitations such as transportation, sizes and breakage, I became a multimedia ceramicist, and fragmentation and de-fragmentation became a new expressive technique through the suspension of elements.

I dance for exercise although not as much as I'd like. I also like gardening, and I grow different vegetables at home.'

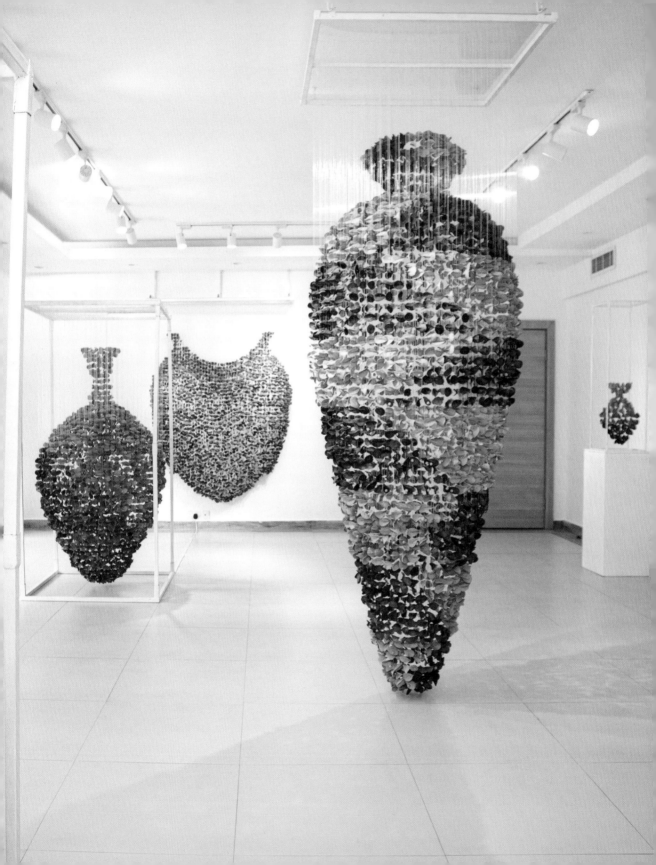

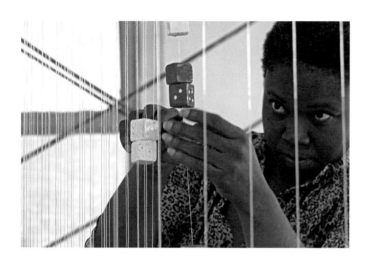

'My technical focus is what distinguishes
me from other ceramicists.
We all use clay but for me making multiple
clay shapes is like being a farmer who tills
the soil.'

'Challenges are sources of inspiration, so my themes revolve around life's turmoil. They focus on the lives of longing women held back by inhibiting restrictions. For this reason, in 2007 I started to think about my challenges and specify the emotions that arose, finding ways to heal that transcended the physical body like a work art.

To come up with ideas I use clip boards and sketches. To combat creative blocks I sweeten my mind with food or cookies while I look at images or leaf through a book that contains different works of art. Creativity is based on being able to communicate your feelings and thoughts and to make your imagination visible. My inspiration comes from making my emotions tangible. From transforming experiences and dreams into objects to share, argue about, and connect.'

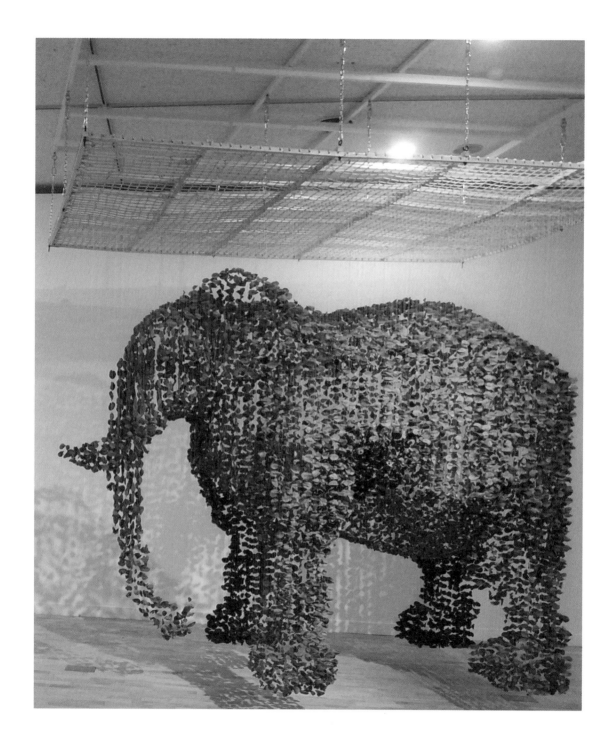

Ana Felipe

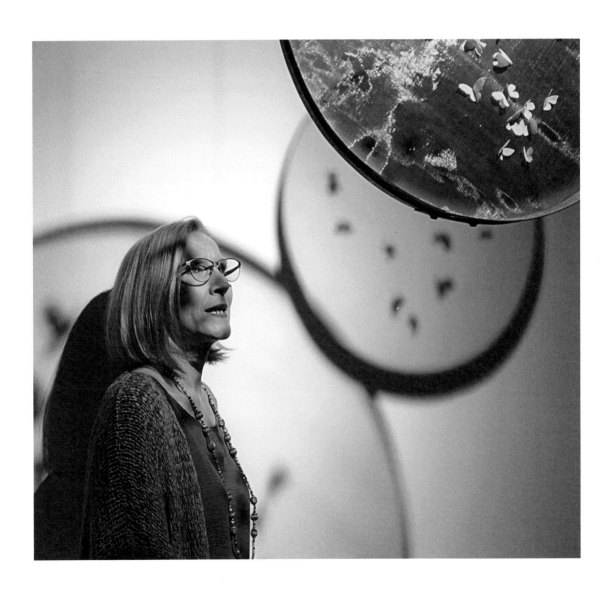

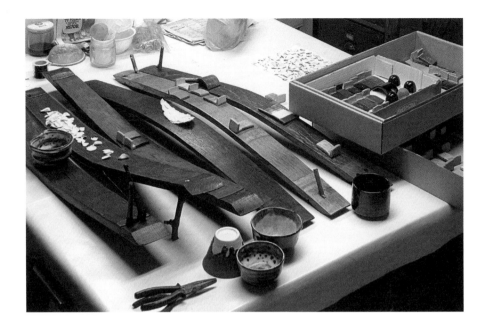

'My work is free, intimate, in search of an identity, filled with contrasts and sensations. In continuous evolution.

I play with different materials in combination with ceramics. I'm very interested in the dialogue between ceramics and wood, iron, elements that make up my surroundings, both if they come from nature or if they form part of the rural environment in which I live. I strive for the integration of materials, or the contrast they create to enhance plasticity and sensations.

In addition to the more artistic and personal work that I identify with most, I spend a lot of time on what I call "food work" (the kind which very often allows me to eat). This work includes mural commissions, practical pieces, miniatures, and research jobs about ceramic techniques and materials. Teaching ceramics and engraving at different schools and universities (I'm a lecturer in the master's degree program "Ceramics; Art and Function" in the Fine Arts Department at the University of the Basque Country) is another facet of my work.

I don't work only with ceramics. Engraving, photography and teaching are also activities which are important to me and which I'm committed to.'

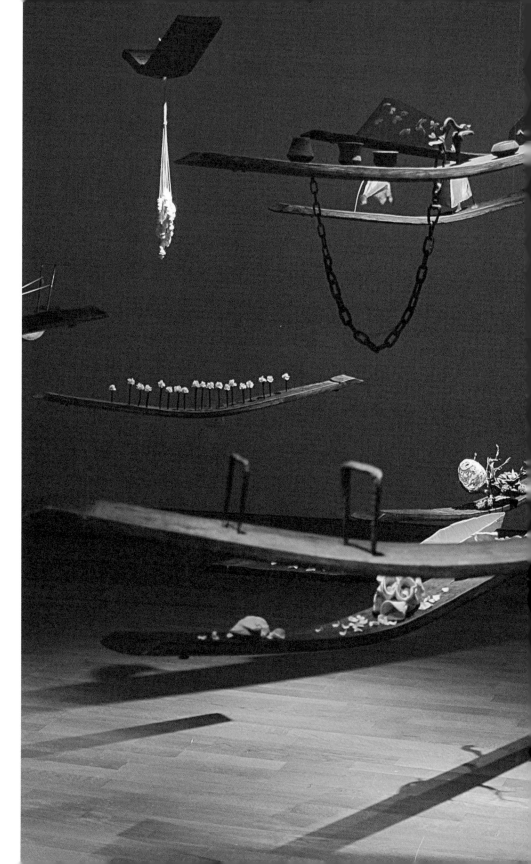

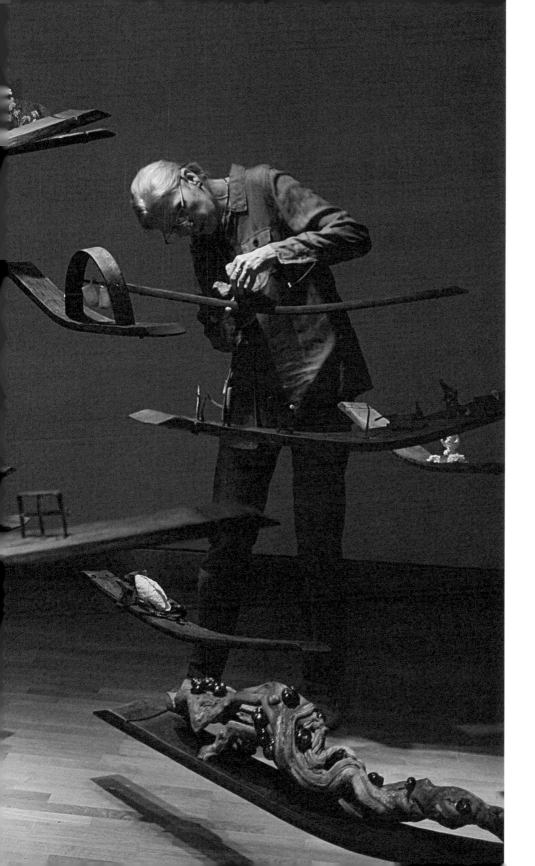

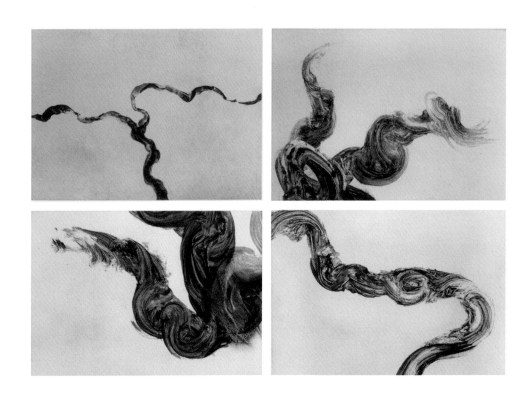

'The secret to being a good ceramicist is not thinking it's a secret. As I learned from my teacher Enric Mestre: work, work and work.

Continuous practice unravels many enigmas, teaches the trade, refines skills, forces analysis, resolves conflicts, and in the time dedicated to routine processes (kneading, retouching and brushing...) gives the mind space to dream, to reflect, to rediscover itself, and to return to embarking on the adventure of creation.'

'Creativity is based on the personal need to communicate, and that this communication has an identity, something which defines it and makes it special to grab the recipient's attention.

The best ideas come from honesty, from trying to be oneself, wanting to transmit personal emotions and values, what one truly feels.
Immersing myself in the past, in my surroundings and wanting to project a future.

I'm inspired by everything around me, what I see and what I feel. Reading, music, emotions, the change of the seasons, observing, reflecting, memories, dreams and the environment I live in. My struggle is to find more time to be able to develop what is percolating in my head.

Play is very important in my work. I always start with an idea, which tends to be clear. But to express it, the search for the materials and techniques to unveil the result and wanting to show more with less, is always a game.

One that's also schizophrenic, since sometimes I'm a creator and others an observer. Empathy, and the game of putting myself in the place of the observer and recipient of the message is common in my daily life.

Mistakes are never in my case a result. Rather, I see them as an essential part of the process. A mistake is always something to analyse, to learn from, to improve the result.'

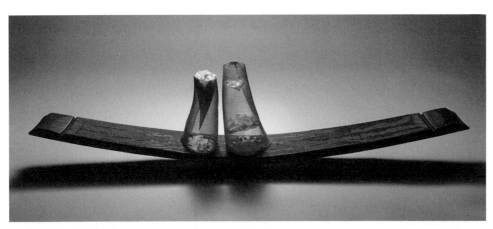

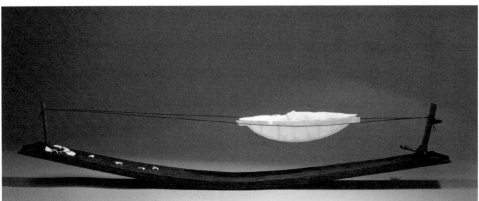

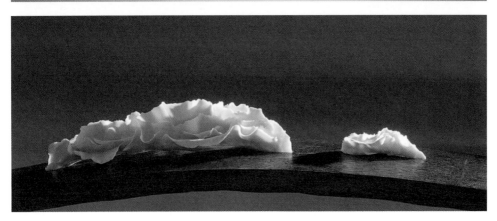

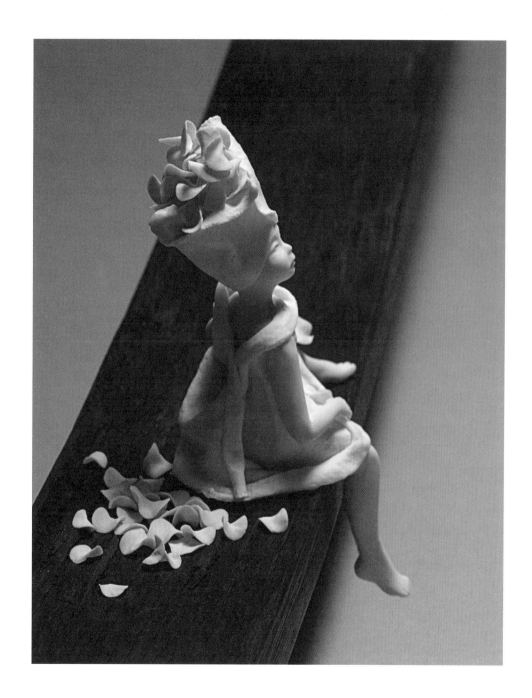

Myriam Jiménez Huertas

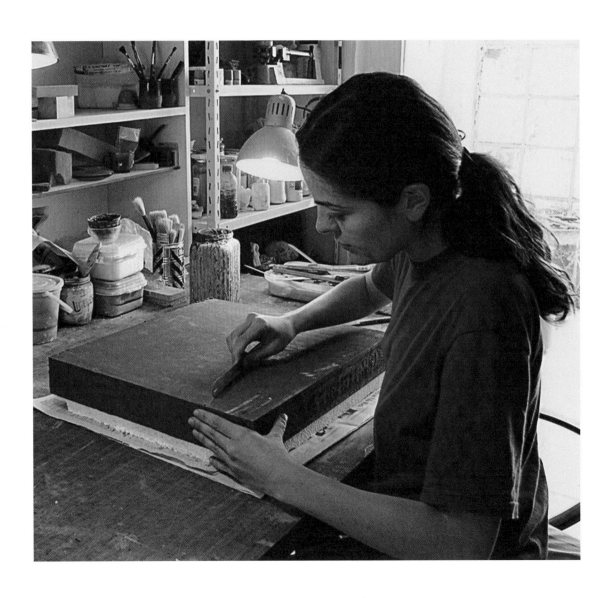

'In my work I try to create imaginary spaces in miniature where I find balance through observation and silence. My interest in minimal art leads me to search for simple basic forms of architectural or geometric inspiration on which all the movement and rhythm of the whole work is based.'

'Normally, I work with series where I develop and try to go in as much depth as possible in the evolution of an idea. These series coexist in time and space, and I've never considered any one finished. Although it's possible that some of the series have more to say than others or at a specific moment in my life interest me more and for that reason I pay more attention to them. Aside from the different series on which I structure my work, there are two large and obvious divisions. On the one hand are pieces where I work with vegetable elements and on the other what we could call "architectures".

In pieces where vegetable elements predominate, such as the series of *gardens* or *mirages*, I try to appreciate the most imperceptible beauty of nature, the small petals or delicate leaves that require lowering oneself to the level of what is small and staying there contemplating for a long time to understand their meaning. The garden isn't only the fruit of an external observation, but internalisation of the landscape, a contemplative digestion prior to any gesture. I try to colonise wild space, transforming it into timeless metaphysical gardens rationalised by my hand with the aim of reiterating its beauty.

In the series *Interior Spaces*, clearly inspired by architecture, we find ourselves before courtyard mazes where light plays with its angles and edges, sharply defining its geometric contours. A deep sense of loneliness dominates these spaces, interrupted only by the darkness and depth of its doors where the gaze is drawn as if somebody were hiding inside. But the loneliness is absolute and the emptiness is only filled temporarily by the observer's gaze.

The use of the colour white is also crucial in my work as a synthesis of all the colours and a symbol of the absolute. The white bodies give us an idea of purity and modesty; they create a luminous impression of emptiness, infinite positive.'

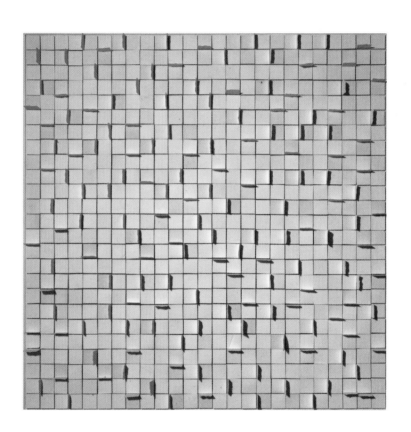

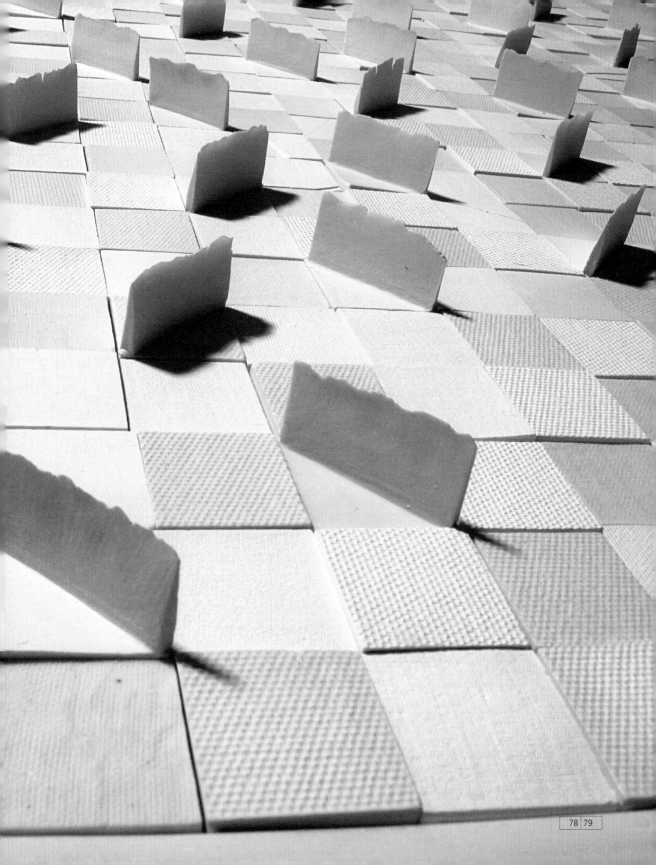

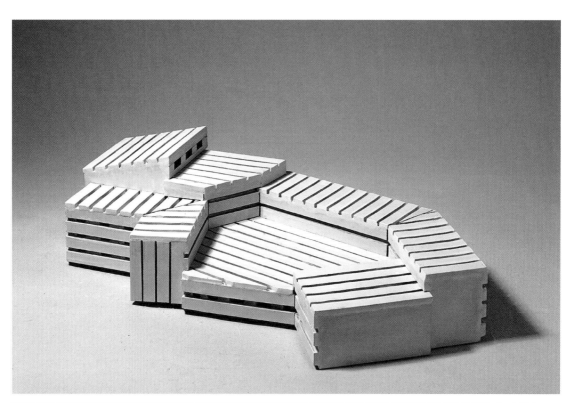

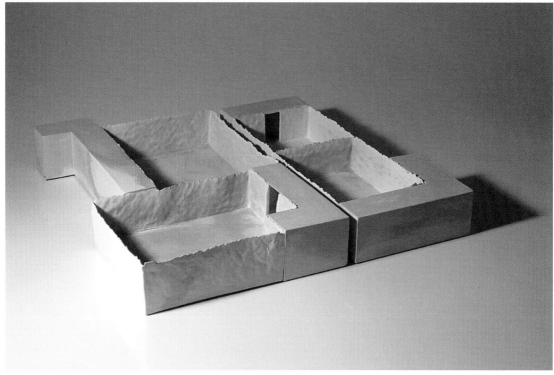

'After a long trajectory of mistakes, which helped me to continue learning and evolving in my work, I think the key to being a good ceramicist is finding a balance between creativity, technique and "mastery" of the material.'

'For me the creative process is one of observation, internalisation and imagination. There are shapes, planes or patterns in our everyday urban spaces that I find attractive, and little by little they gestate inside of me without my being aware of it. Then a day comes when they are ready to see the light. At this point I now consciously try to adapt them to the material I work with, ceramics. Pottery is a material rich in qualities and textures that can offer limitless possibilities in finishes. It's a world that's so wide and magical that even if you've been working in it for years, you'll never master it completely.

When I started working with porcelain its whiteness and translucence captivated me. For years I would adapt all of the shapes and ideas that popped up in my head to this material. It wasn't easy. I wasn't completely satisfied with the results but, for some unknown reason, I continued to insist on working with it, until I realised that all the technical limitations of porcelain were also limiting my creativity. So I dared to make the leap to start working with modelling clay that was more compliant and could better be adapted to what I wanted to do. I believe that because of this change, previously unimaginable work possibilities opened up to me.

When I have a creative block I don't tend to be frustrated by it because I view it as related to mental fatigue, which sometimes happens to me when I work continuously for a long time on a single project. My solution is to change the series and let the previous one rest for a while. Then I end up returning to it with more interest and refreshed ideas. Looking the other way for a while usually proves to be quite effective.

As for the series about architecture, the creative process is different than with the others. It's a more intimate process where I try not to pay too much attention to the external and focus more on what emerges from inside of me. I like designing in my notebook plans for imaginary spaces that aren't going to become actual architectural structures, which gives you a lot of freedom to play on paper and create fantastic forms. It's a fun process.'

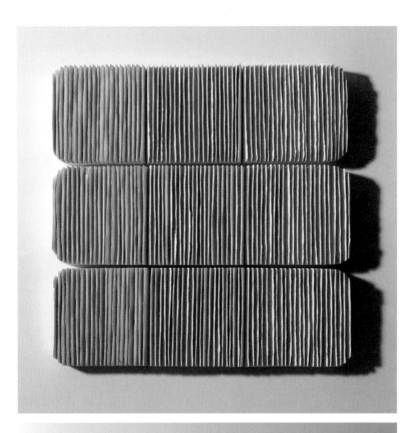

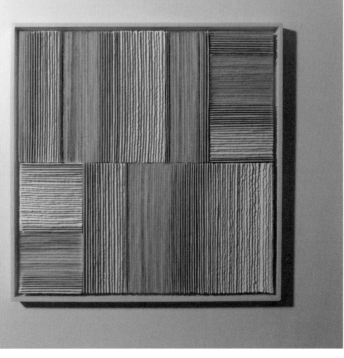

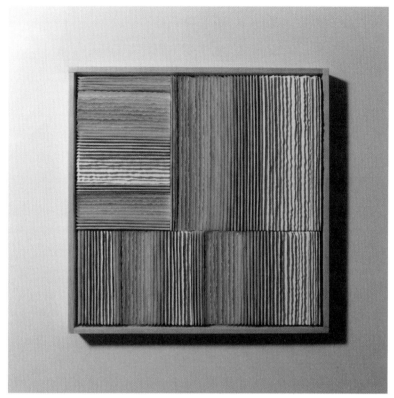

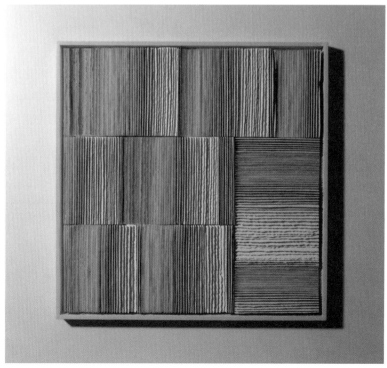

Cecil Kemperink

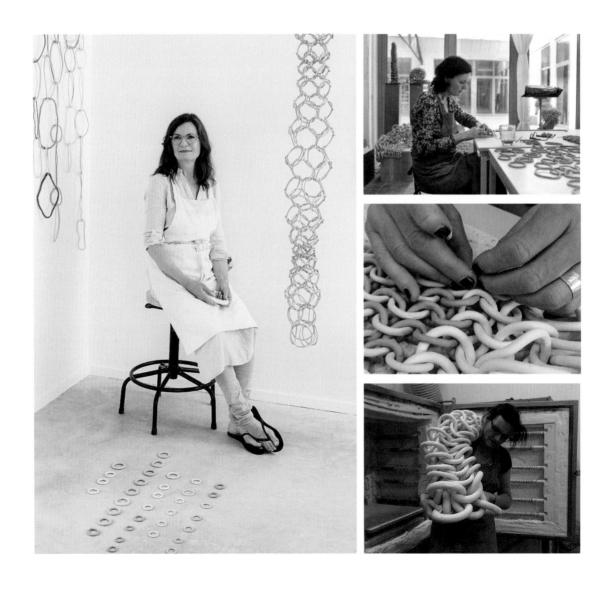

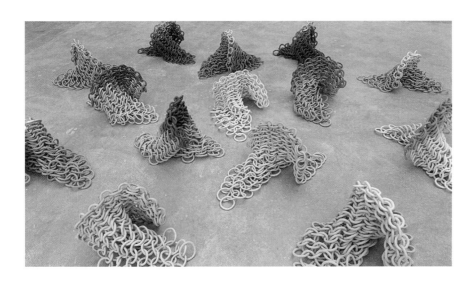

'I studied textile and then fashion for a year. And when I was younger I wanted to be a dancer. I think in my sculptures, my multifaceted training is apparent: they show the connection between my different passions.'

'My ceramic pieces are interactive. You can see, hear, take, feel, play and experiment with them. I create sculptures with multiple shapes, multiple sounds, multiple perceptions. Their form can be changed. You can play with them, touch them, feel their energy and listen to their sounds.

What's essential for me is that when you touch the sculpture, you change the form, you are part of it. You connect and interact. So my work also has to do with the observer. You are part of it.

I love playing with clay, the form, the sound, the time, the kiln, the colour, the rhythm, the space. With the movements and the way it moves.

I'm very inspired by the rhythms of nature, the waves, the tides, the day and the night, and also breathing and heartbeats.

I love surprising myself. I work intuitively. When I start on a sculpture, it grows in my hands. I love playing with contradictions: vulnerability and strength go together.'

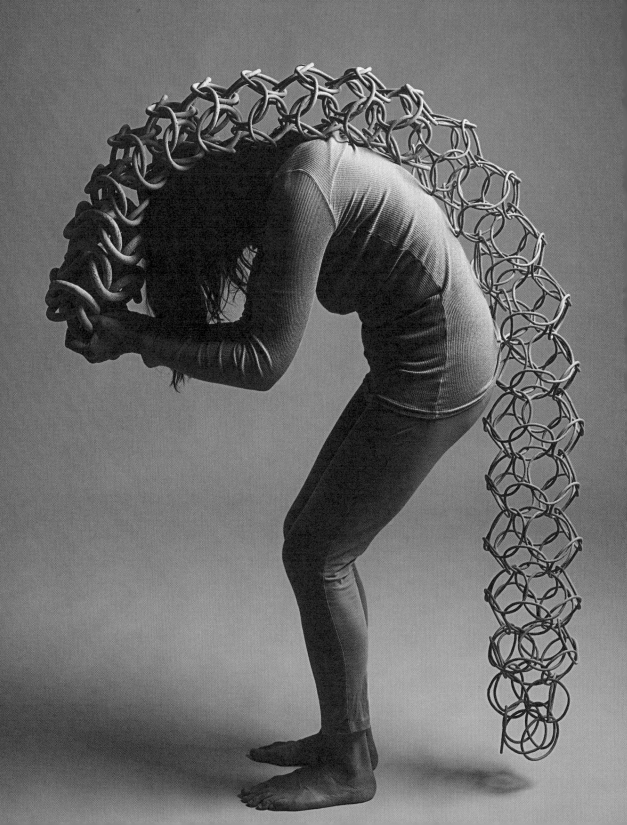

'Patience. My work has taught me to be patient.
Doing what I do requires a lot of time and
attention: and I have it! In my personal life I'm
not as patient. Clay grants me patience.
I'm determined to make, to create, and if this
takes a long time, then so be it. And I keep at it.'

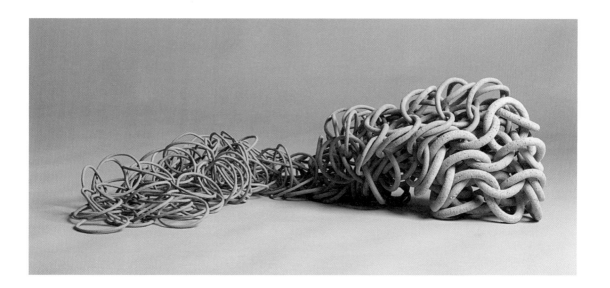

Great rhythm

'An important piece, because with this idea I looked into the how of movements.
How sculptures move. Which movement I make and how the sculpture follows me.
Am I the director? Or is the sculpture in control? How is an exchange possible?
You watch the shape breathe and its breath sets the sculpture into motion. The sculpture moves
because it breathes and movements begin. They actually transform into one.

Building process: a sculpture that has fifteen different elements, exploring form, space, colour and
colour transitions. So many different forms are possible.
The interaction between the sculpture and the woman/man opens several layers of consciousness: each
relationship reveals new sensations, an emotional change, and a different energy. New perceptions are
formed, many points of view emerge. Consciousness is in full movement.
When the work is completed, it isn't finished, because I have to figure out how I want to show it.
In a photograph and/or a video.'

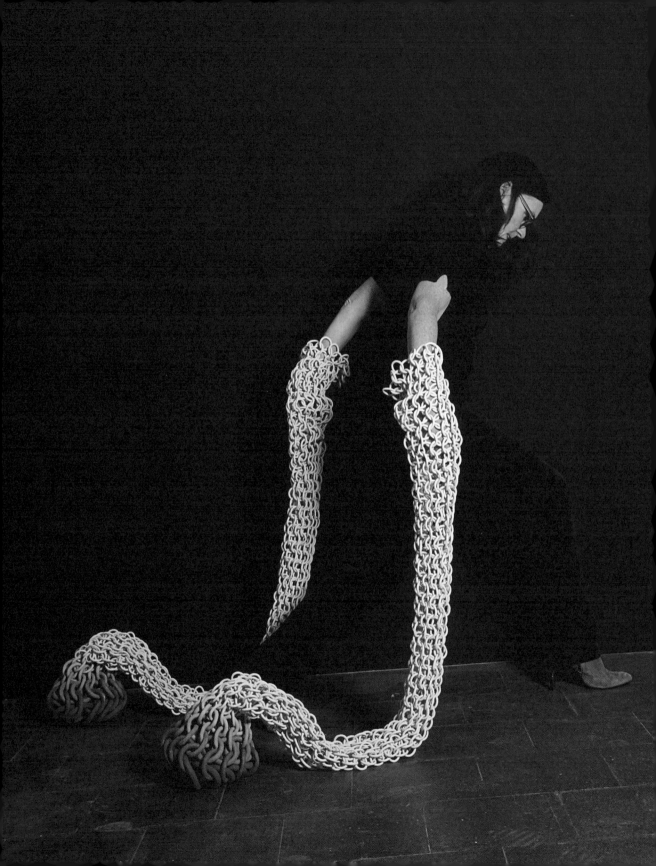

'Creativity is based on having an open mind, keeping your feet on the ground and respecting yourself. And the ability to create new connections and see new possibilities. To see and act beyond what is known. I've learned that the truer I am to myself, the better my sculptures are.'

'Ideas come from different sources:

1: From my own sculptures: When I work on a sculpture, what transpires gives me new ideas to explore. I make a choice, but there are numerous options...

Sometimes I create series. In this way I give myself the opportunity to make more sculptures (to research more alternatives). I'm very curious about what the clay will do: What will the colour be like? The sound? How will it move? How will I dance with it? Where? So many questions all the time. What I finally decide on is the alternative that makes me feel good, that gives me a feeling of joy.

Each sculpture leads to another. Move. Moving with my sculptures is way of discovering my work, and it guides me to new forms, sculptures and sounds.

2: Ideas literally come from everywhere: at the end or the start of the day, in the shower, in the tub, during a conversation with someone.

The last idea: when I was with my singing teacher and we were talking about the richness of the colours that you can hear in a tone. A sculpture was born!'

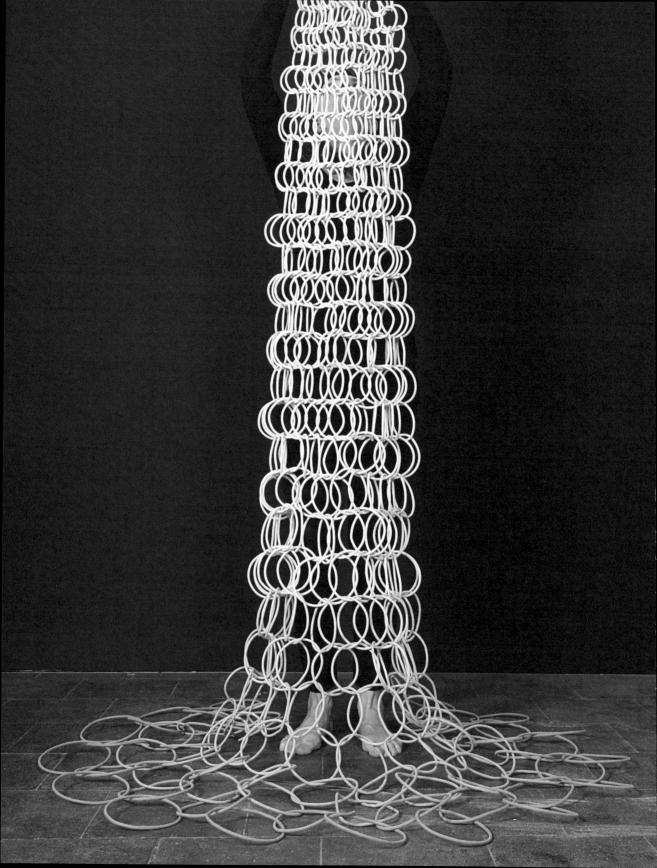

'The secret to being a good ceramicist is the relationship you have with the clay. The desire to explore and discover. To find your own path, your own style. You're the only one that can be you. Believe in yourself.'

'I'm inspired by nature. The rhythms of nature inspire me. Every day I see and experience so many changes. The waves paint beautiful pictures in the sand. The beach holds them for a while, before the wind and the water change their design. Again and again. Silhouettes of branches dance with the wind. Sometimes violent and difficult to see, other times serene and clear. Nature knows what to do and when to do it. Sometimes noisily, sometimes slowly.

My method for coming up with ideas: be still and focused. Meditate, walk. I also make mental maps. I use a large piece of paper and lots of colours and materials to write and draw. Luckily, I have a huge creative source inside me. I care for and appreciate this tension.

At the beginning of my career, I would make sure I was working on several sculptures simultaneously, so I always had something to do, regardless of my mood. Always something easy — clean, polish, experiment.

Play is probably the most important activity in my studio. At one point, years ago, I was working and working, for clients, galleries, exhibitions. And I discovered that I was working to obtain results and was forgetting the process and the joy of creating. So I gave myself half a day to play. No pressure, no clients. Just the clay and I. And this was so, so important for me. It "opened" me again.

When you're an artist, you want to find your own form of expression, so to speak, your own handwriting. Your own form of expression is the most important thing. Because that's who you are. It's not written anywhere; you have to discover it yourself. And this is scary, and at the same time it's the best thing you can do: your own way of expressing yourself.'

Kaori Kurihara

Photography: Sabrina Budon.

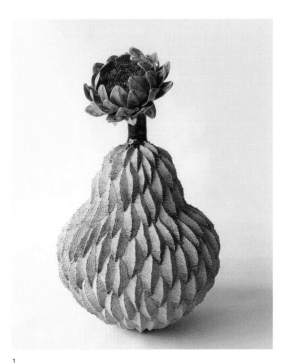

1

'I don't draw anything beforehand. I let my work grow freely, and I don't know the shape or colour until the process advances. I want to express the brilliance of living things because I'm alive.'

'The origin of my creation is the natural world. More specifically, it's a beautiful series of vegetable worlds. I've been working on this series since I was fifteen. The first time was an encounter with the fruit called durian. At the time, I didn't really understand why I was attracted to the shape of this fruit. I kept looking for and observing patterns that inspired me visually. After about ten years of exploring and creating pieces based on my feelings, I finally realised that I was attracted to the sequence of worlds that exist in nature, like the golden ratio. The good thing is I wasn't searching for this as knowledge or an academic point of view from the start. If I had researched it at the beginning, I think creativity and freedom of thought would have disappeared because of the knowledge.

After realising what fascinated me, I discovered that my sensory knowledge wasn't mistaken when analysing and reading information about plants. And also it became clear that the core of the fascination is whether it's alive or has vitality. Now, what I need to create a piece of work is knowing up to what point I can have a sense of how plants grow and behave. When this sensation is clear, I can grow like a plant while creating. I think it's similar to plants that don't ask themselves what kind of flowers will bloom in the future.'

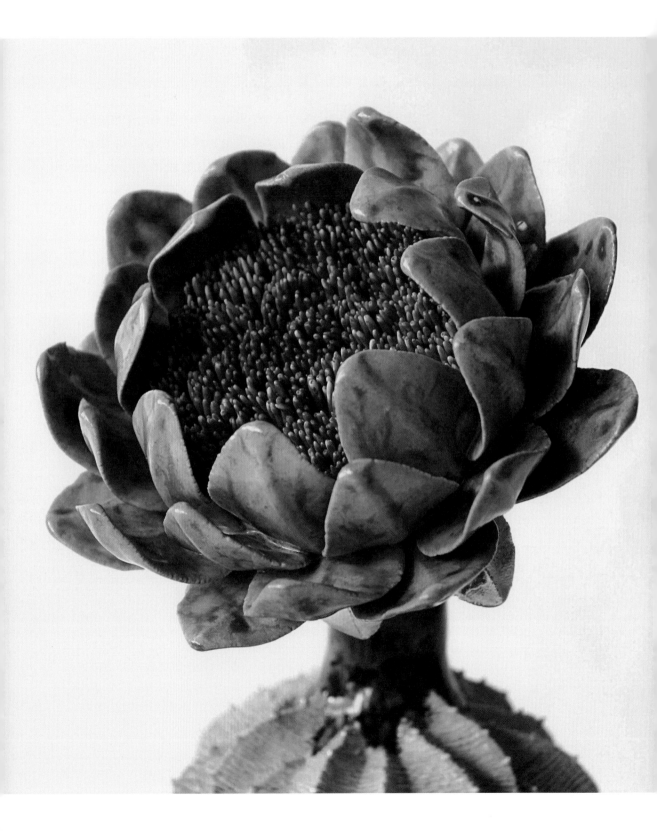

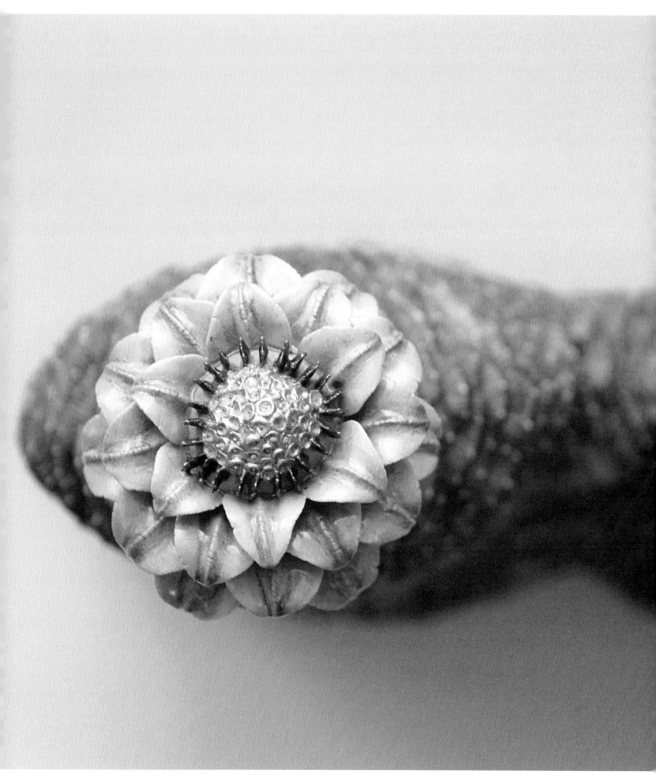

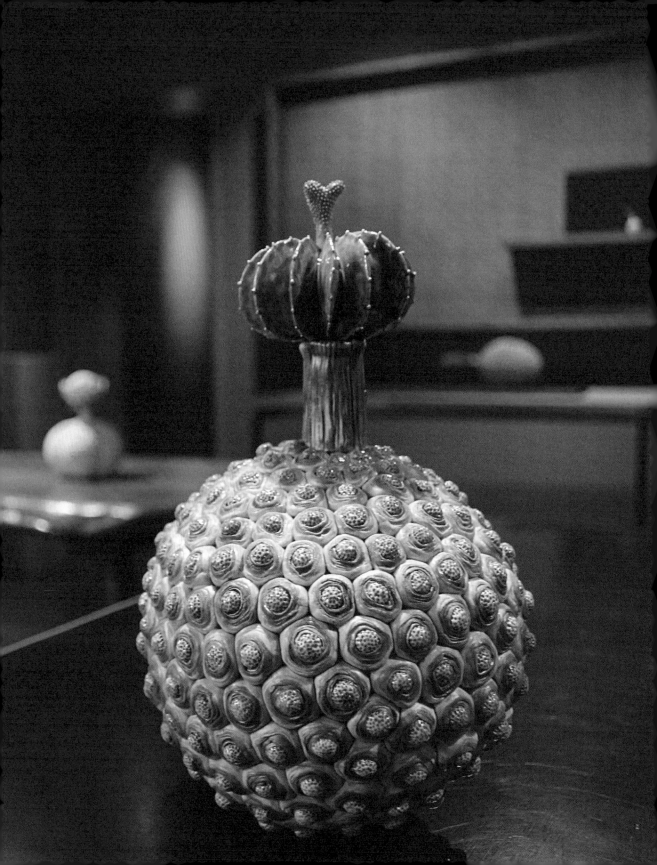

'So far I haven't struggled with creative blocks. To the contrary, maybe it's because I haven't been an artist for very long. While the subject remains plants, the motivation will persist as long as there are plants in the world, and the brilliant feeling of living beings will continue while I'm alive.

Play is part of the process. My role in the work is that through my perception to feel the things that resemble the soul of the work that's about to emerge. I feel intentions clearly. Then I use my perception and my hands to help it take shape in this world. The soul of the work itself already exists some place at the time of the encounter with the work, and I incorporate it into my inner self through a deeply felt communication. "Thanks for trusting in me" is what I feel.'

1. *Spring morning, girl with hat.*
2. *Cactus cloud.*
3. *Clown.* Solo exhibition *Garden Party*. H Gallery, Switzerland.

3

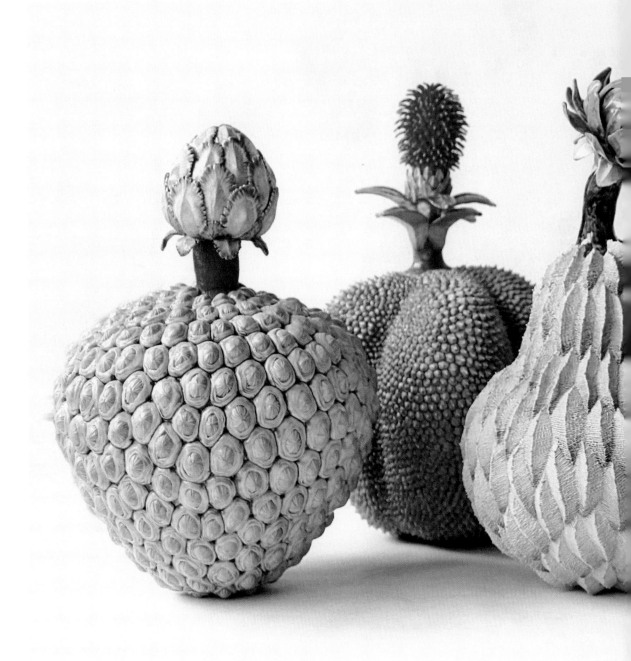

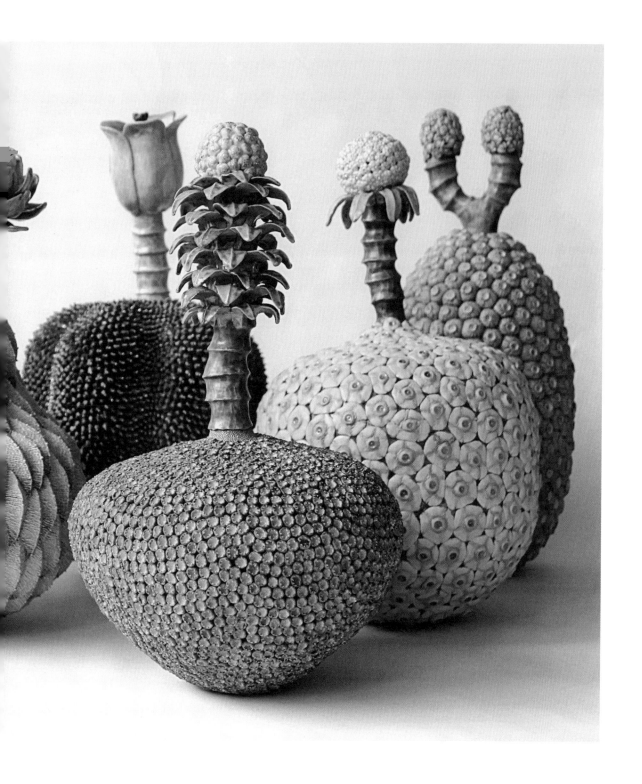

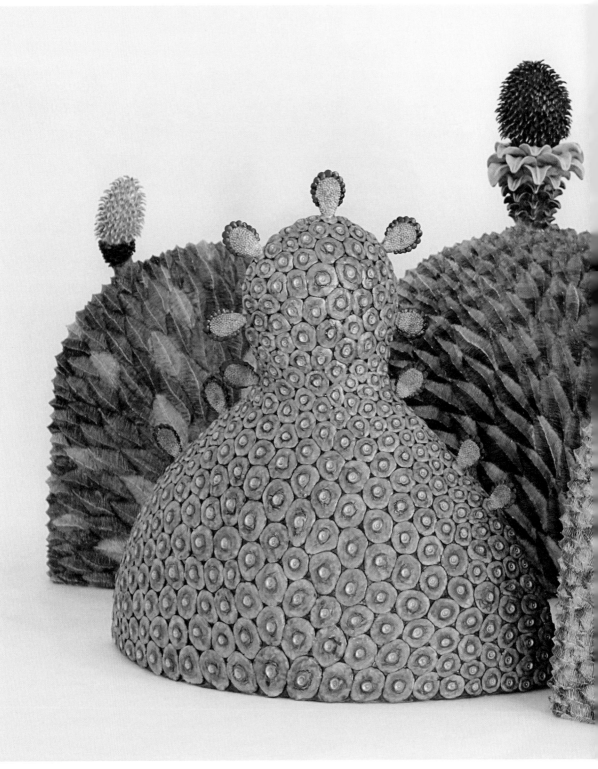

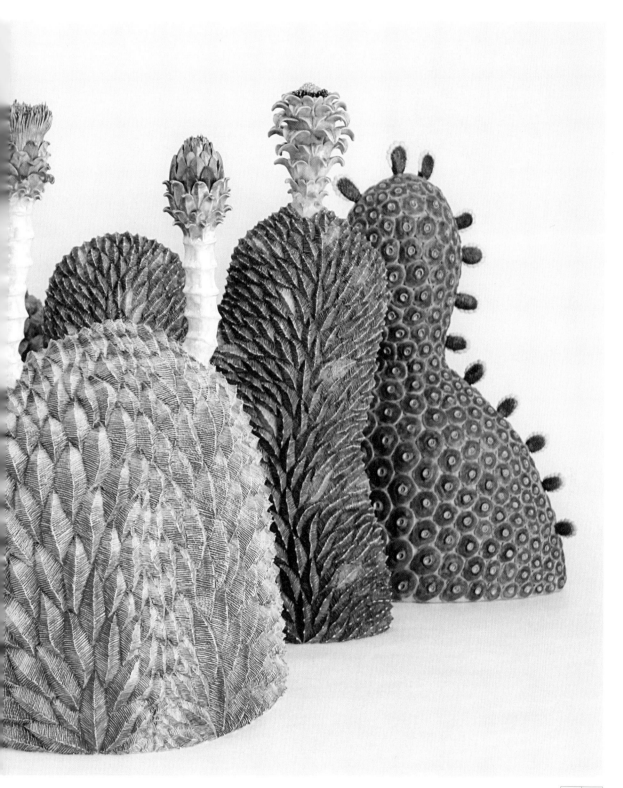

Nicholas Lees

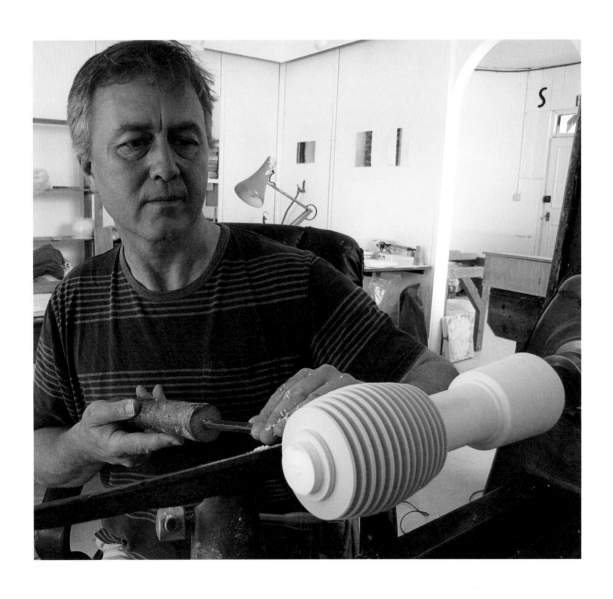

1

Nicholas Lees has been working in the ceramics field for thirty years. During this time, he has produced numerous works in diverse disciplines, including studio pottery and sculpture. His working method combines a deep knowledge of the medium with skills developed over a long period of time, to create aesthetically distinctive sculptures with a strong conceptual foundation.

His work has been exhibited in many countries and forms part of such important public collections as the Fitzwilliam Museum in Cambridge, the Museo Internazionale delle Ceramiche de Faenza (Italy) and the Westerwald Keramikmuseum in Germany. Among other awards, his work *Four Leaning Vessels* won the prestigious Cersaie prize at the Premio Faenza 2015.

He has consistently engaged in the academic study of ceramics, returning to education to further his practice as an artist. Over the last twenty-five years, he has contributed significantly to higher education in ceramics in the United Kingdom, having held a position as a senior lecturer at the Bath School of Art and Design. Currently, he teaches at the Royal College of Art in London and at the University for the Creative Arts.

2

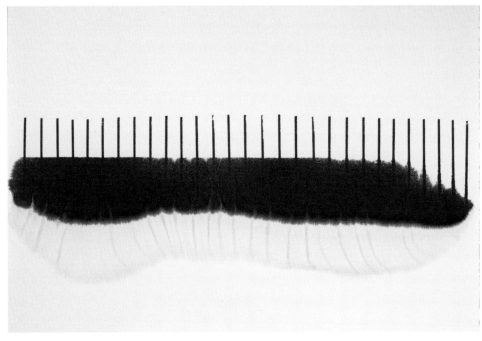

3

3

4

1. Cast shadow.
2. Hedge.
3. Drawings, ink and water on paper.
4. Sketches, ink and water on paper.

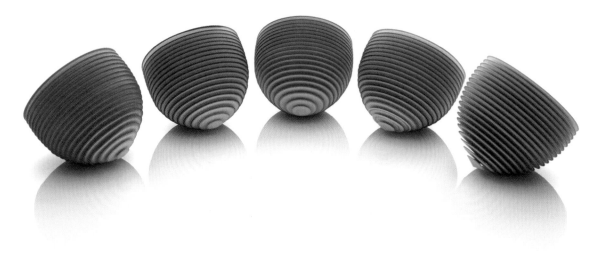

5

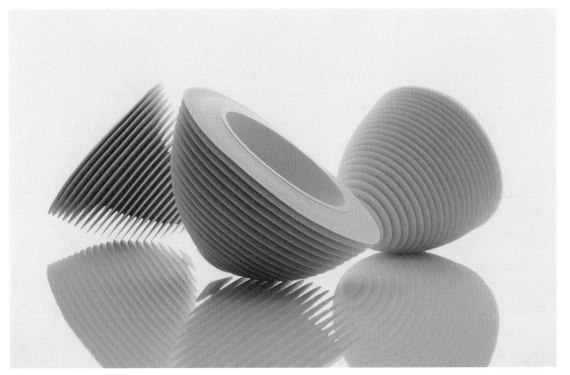

6

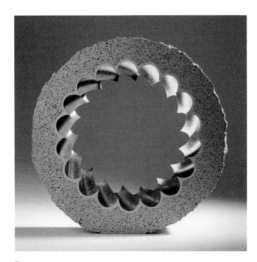

7

'For me, creativity is driven by the desire to be an agent of change, to find ways of bringing objects into the world which previously I didn't know could exist. The path towards creating new works of art involves asking questions, rather than trying to make something that resembles or visually represents a known image. These questions can be technical, visual or philosophical.

It's also important for me that ideas are inseparable from a commitment to the material and the process. I think through the activity of making. It's where questions are answered and new ones are posed. My current work emerged from a research project at the Royal College of Art in London. In it, I was looking for a way to create something new, a progression from earlier pottery and sculpture. The combination of rigorous questioning and critical reflection with playful experimentation proved powerful in finding a new path.

I'm interested in boundaries and transitions. At first, I questioned the nature of the transitions between two and three dimensions, and this led me to think about shadows and silhouettes, which are fascinating phenomena when considering the relationship between dimensions and physical and imagined worlds. The limits of shadows, the penumbra, are captivating, and I began this work asking myself: How can I make ceramics be somewhere in between? How can I have an object inhabit the interface between presence and absence and so question the act of perception?'

5. *Five coloured Floating Bowls*, 2021. Paros porcelain and metallic salts, H13 cm. Photography by Sylvain Deleu.
6. *Three Floating Bowls*, 2016. Paros porcelain (earthenware), H 23cm. Photography by Sylvain Deleu.
7. *Air*, 2008. Stoneware ceramics and gold leaf. H 63cm. Photography by Jason Ingram.

'My work is also about time and the way perception is conditioned by it.'

'Throughout my entire life, I've visited the same stretch of Scottish coast, and this has had a profound effect on me. The coast is a place of transition as a meeting point between the land, the sea and the sky. The constantly shifting conditions of light, the tides, the weather, the seasons and my passage through time means that the view from the same place is never exactly the same thing twice. I try to capture the combination of permanence and ephemerality.

As I said, my work ideas have evolved through the act of making. Ceramics is a very rich and fascinating medium, given that you can work with it in so many different states and through such a wide variety of processes. I like the transition from the soft plasticity of porcelain to the resistant material in its semi-dry state.

My pieces are sculptures created through a pottery process. They are thrown on the wheel as very thick proto-objects and, after a slow drying, they are turned on a lathe, in a process that can be traced back to early industrial production of ceramics in Stoke-on-Trent. Lathe turning requires a lot of skill and patience. In the interplay between the maker's mind and hand and the material it is the point at which control is most intense. I work carefully and precisely to achieve an effect that challenges the eye. Later, I enjoy the small amount of movement in the form produced in the kiln: the push back of the material and the process.'

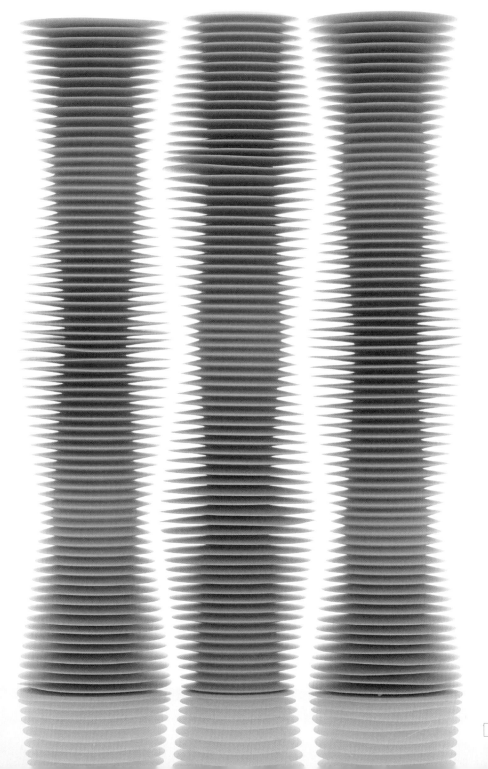

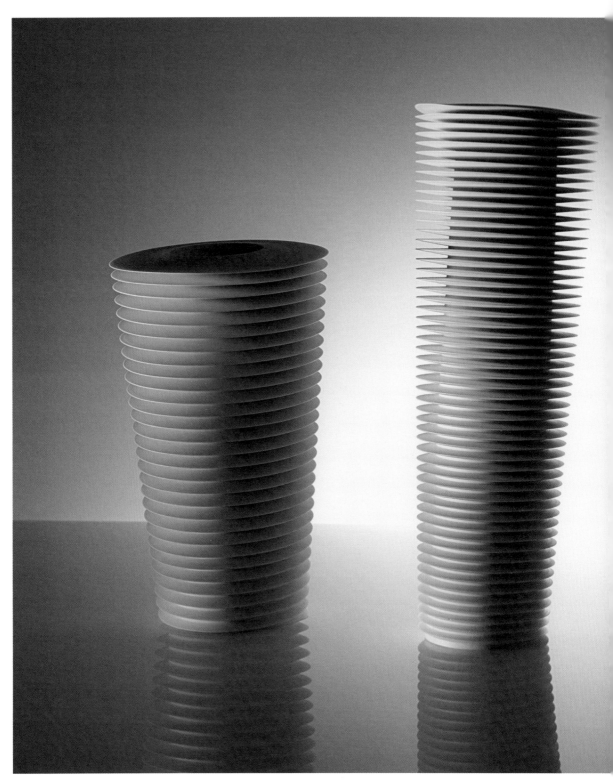

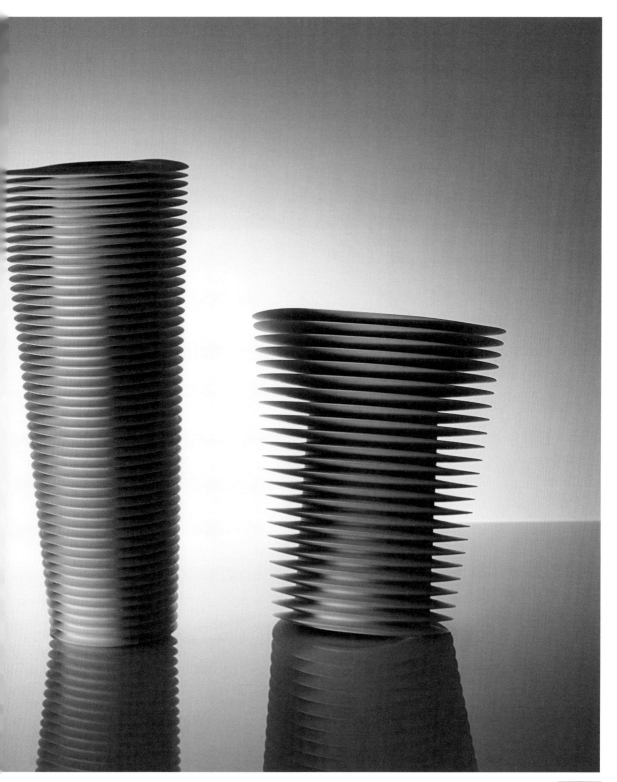

'My work has become a question of perception and of relationships between porcelain, light, space and the body: sculptural and architectural concerns.'

'Many of my pieces are monochrome, reflecting their origin in ideas related to light and shadow. However, when I use colour it is in a process that involves soluble metallic salts that travel through the ceramic object from the inside to the outside via saturation and evaporation. This use of porosity to obtain a surface finish that appears through the form instead of being applied to it is related to visual porosity and uncertainty of the presence of the form. This derives in part from my work on paper, which is a parallel activity to the production of ceramic works instead of a preparatory stage. I use ink and water to explore the same ideas in a faster medium, producing a different recurring rhythm of idea and outcome.'

8. *Four Leaning Vessels*, 2015. Paros porcelain (earthenware), H 63cm.
Collection of the MIC Faenza (Italy). Photography by Sylvain Deleu.
9. *Grail*, 2021. Paros porcelain and soluble cobalt, H 24cm. Photography by Jon Furley.

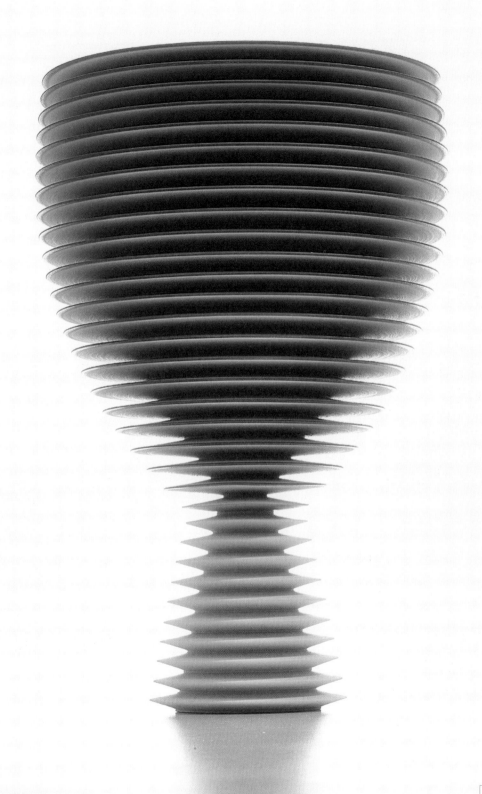

Wan Liya

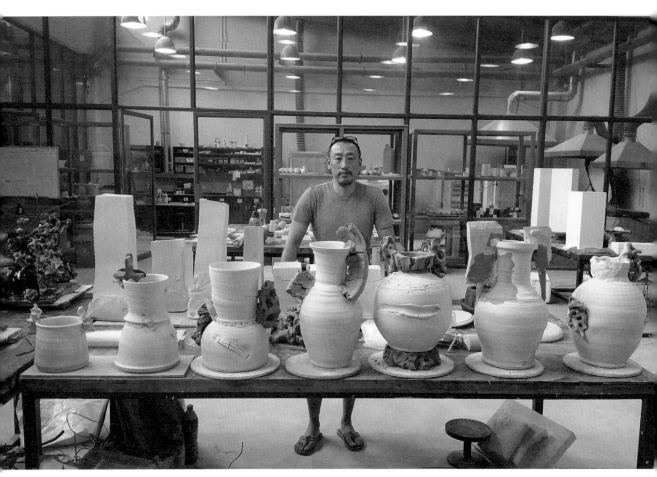

Photography: Olivia Fougeirol.

'Until now, my experience with ceramic art can be broadly divided into three periods. The first period was from 1989 to the end of the 90s, focusing on the study of ceramic technology.

The second period consisted of using ceramics as a medium to find a meaningful connection and a personal artistic style between Chinese traditional ceramic culture and modern artistic expression to express lived experience subjectively.

The third period involves eschewing subjective expression as much as possible, returning to the properties inherent in ceramics and discovering the relationship between the intrinsic regularity of the objective material and the individual spirit.

My work is defined by its personal nature, the experience of growth, and the way of feeling the world.

I like sailing, delicious food and copying Buddhist texts in Chinese calligraphy.'

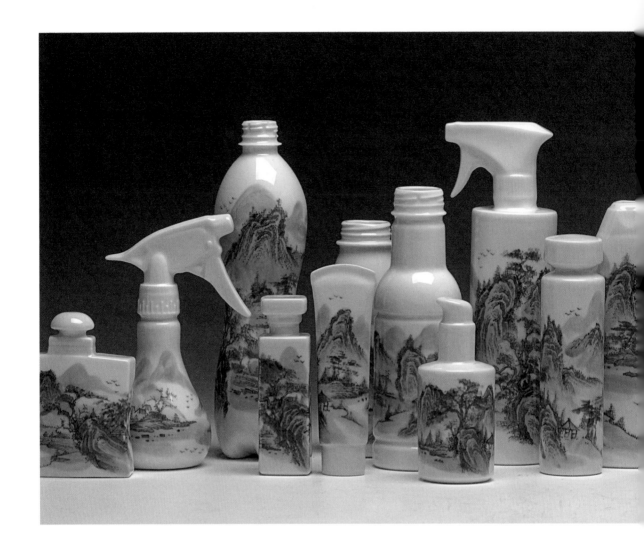

'The secret to being a good
ceramicist is to be free and without
constraints, to enjoy the work.'

'Ideas come from the accumulation of knowledge, typical events and interesting stories stored in personal memory and other related information, ceramic skills and experience, intuition.

Ideas emerge from continuous work. I'm inspired by the connection, guided by intuition, between the reservoir of information and some aspects of everyday experience.

Mistakes are an important channel for discovering unexpected worlds.'

1. Porcelain sculpture *A National Treasure,* creation process.
2. *A National Treasure*, 2011. Exhibition *Contemporary Chinese sculptures*, The Hague (Netherlands).

Ícaro Maiterena

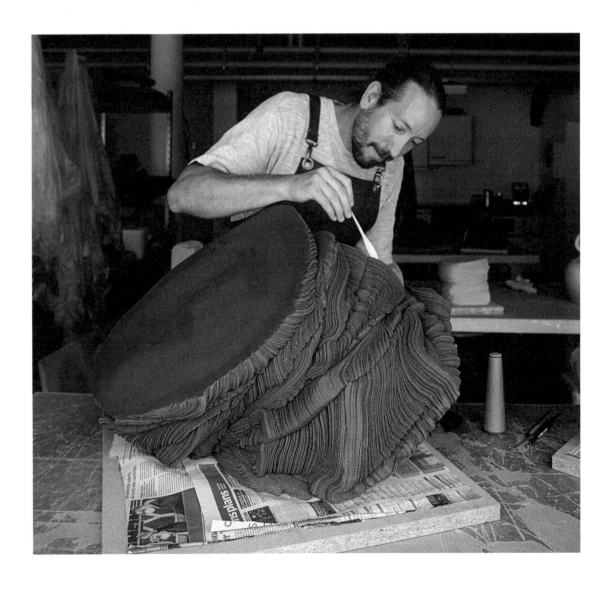

'I'm inspired by the mystery of humanity and nature. I work mainly with traces, with imprints, with vestiges and with the memory that survives in them. Touching the world leaves traces. Traces to understand the world, what surrounds us and what happens, our place in the whole.'

'I chose this path with the intention that my way of being in the world was "making, creating". I began carving stone, co-creating with dancers and musicians as a set designer.

To learn how to sculpt, I became a master stonemason. Being an artisan was an identity challenge. Learning the trade but most importantly being coherent, creating by recreating myself. To search for and find a way to develop my own way of creating, imposing on myself the need to draw from my inner self something that I didn't know and would only come to know if I dared to "get down to business". Allowing myself to flow, without setting specific goals or adhering to a discipline, simply opening myself up to listen to what my own work was telling me to do. Inspired by stones, terrestrial relief, volcanoes, mushrooms and lichen, seashells, seeds, tree trunks. My work was the fruit of experimentation. I considered the results traces of my exploration.

I have an overarching need to make things with my hands, as if it were almost a political act, like a subversion, in the face of the virtual, of the dominance of the visual versus the other senses, of the consumer society that renders us useless and dependent and destroys our social creativity.

This overarching need to make something with my hands connects perfectly with the ceramic clay that gives us a primordial experience of the material, a terrain full of remembrances that take us back to the world of childhood, where everything occurs with a living intuition, and connects us to humanity's past.

When I found myself face to face with the clay, I became aware of my hands and of the inner dialogue, in the very act of making, with matter, earth, water, air, fire, and ether.'

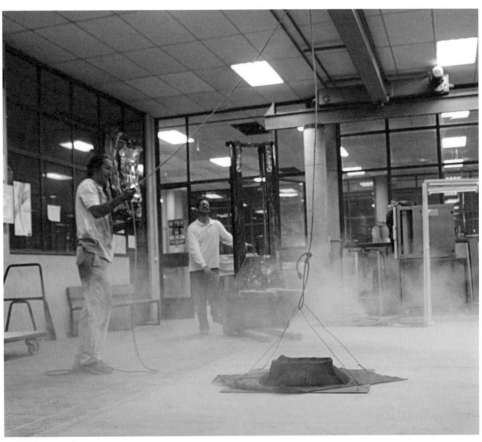

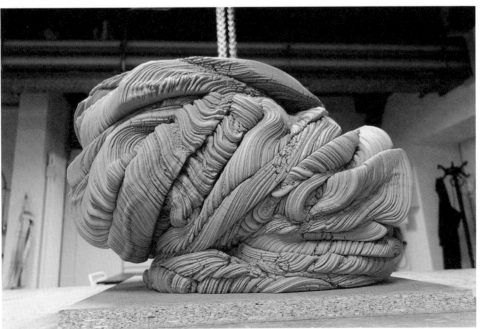

'I see art as a human ability born of our uniqueness. I'm very interested in creating art with others, in collective co-creation.'

'I give myself over to the process in body and soul. I activate my thoughts while shaping the clay, feeling like I'm just another natural element. I act thermodynamically on the clay, pouring out my energy with enthusiasm and courage on it, in a kind of partnership with air, water, and fire. I flow, emptying myself in the "is-isn't", immersed in nature itself, transfigured by the experience of the transformation that takes place in the clay, physics, chemistry, science, alchemy and magic. Inquiring into the trace, the fold, the foldback. Observing, exploring, attentive to the responses of the material and to my own, creating meanings and redefining lived experiences.

I work in alternation with the ceramic material, the salts, the kiln, other artists, people interested in my work, my personal circle and society, learning, imagining alternatives. I think with my hands, apprehending through experience. I'm fascinated by the versatility and vulnerability of the material. Dancing to the rhythm of Deleuze: avoiding synthesis, far from perfect worlds, unlearning or learning from beyond what is felt and known, venturing into loss and emptiness to bring forth self-contained continents, ceramic sculptures.'

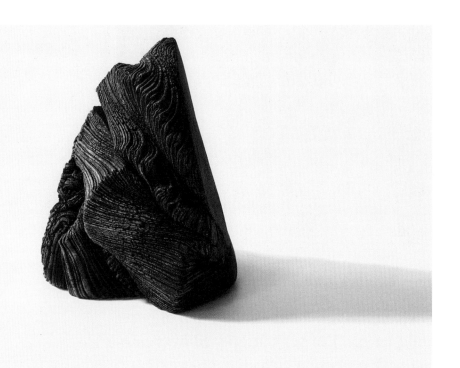

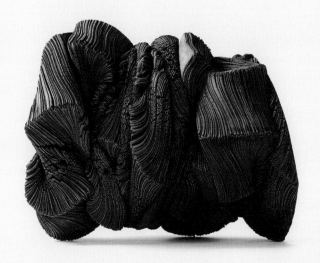

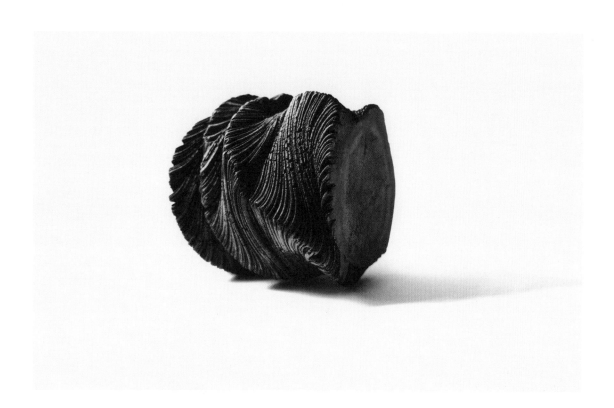

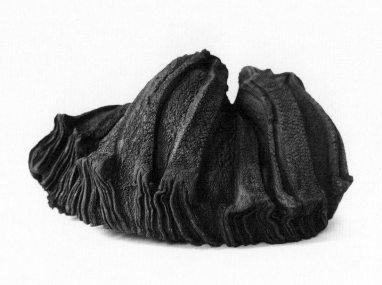

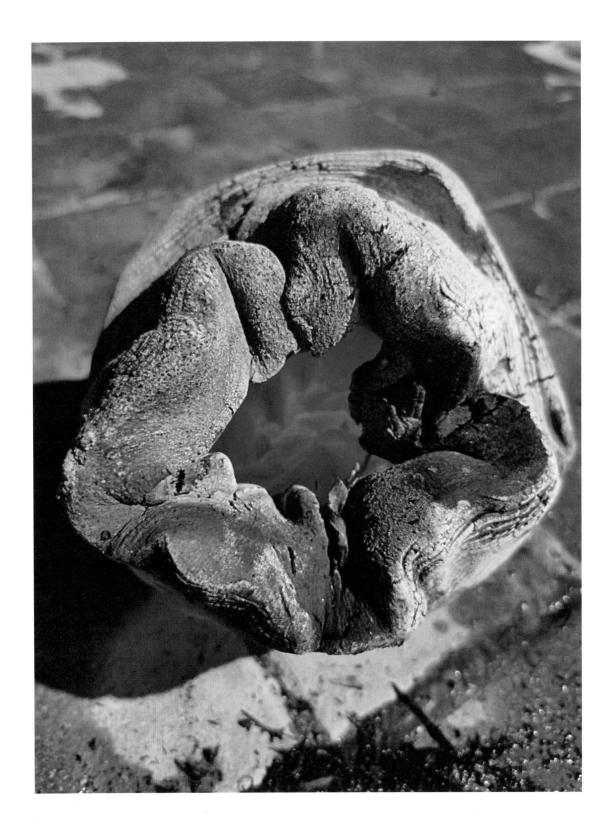

'From the moment we're born we're all creators. We're endowed with biological inventiveness. We aren't born with instincts. We explore and we play. Play and a sense of humour are the two manifestations of creativity that create the deepest bond between us. Play and art coexist in such a way that play forms part of the aesthetic experience both of the artist and the observer and is a communication tool, reaching its peak when we are able to co-create.

"Work which remains permeated with the play attitude is art" said John Dewey. Play is older than culture, and, as Huizinga says, from play culture was born and is born. I believe, from experience during my childhood and from involvement with my son, that there's nothing more serious than spontaneous play. Free, unfettered, spontaneous action which integrates physical and imaginary space, which you give yourself to in a self-absorbed way, totally committed to the present, and then magic occurs. Imaginative topics with their analogies and metaphors imprint themselves on your consciousness, defining and redefining the material. I like to play with the material, allowing myself to be carried away by the skin and what is felt, in collusion. And the work frees the observer's intuition and imagination.

I view the artistic process as a spiritual process born from uncertainty, open to chance, without fear of fear, in the face of chaos, necessity and experimentation. It has a lot of play's freeness, the uncertainty, when you sink your hands into the clay and earth, water, air and fire, and they invite you to dance in the explosion of a volcano of passion, pleasure. Soft, delicate kneading. Blows causing tectonic plates to collide. Immersing the pieces in iron chloride, a blowtorch blast and reductive firing. Stripped of what covered them, deprived of oxygen, chemical, physical and spiritual magic, reproducing the molysite process in the gas emissions of active volcanoes. Thrusting forth oceans, creating folded plateaus, giving birth to a mountain range, solenoid movement, vortexes generating relief, their textures on Mother Earth and three kingdoms: mineral, vegetable and animal.

The artisan, compiling these realms and their elements, the astonishment, the fascination of an intimate, respectful and loving human-telluric relationship that comprises the essence of our reality, fossilised in a work that seems abstract but kinetically shows us representative and expressive traces of the origin, transformations and current tectonic behaviour of our planet steeped in climate change. Pure demiurgical magic expressionism.'

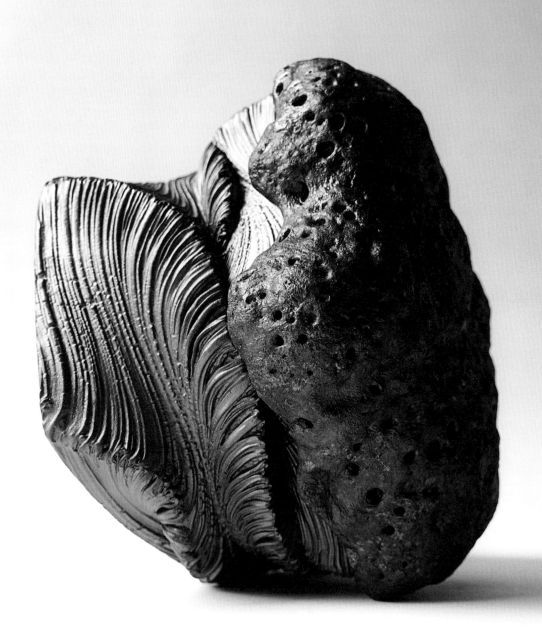

'I'm inspired by life and knowing myself over the course of existence. Our personality is multiple, multifaceted, and often we have to resist rejecting any of these unknown facets of our ourselves, just as we're unaware of parts of our city, facets of the person we love, dark and unblemished areas which have yet to be explored. I'm inspired by this game of delving into the most unknown aspects of ourselves, digging deeply into this vast private world that we all possess, and to travel along unknown roads.

I'm inspired to know that the constant challenge of life is in everyday things. It's in our daily routine where chaos grows and unfolds. I'm interested in the everyday as a place of small fissures. The everyday dissolves the product and the refuse. It's the work within the work, the fleetingness of gestures that escape intention. The space/time in which existence occurs.

The body interests me as our medium for navigating the world, the contextualizer, the point of ecstasy, the axis. Our cells are receptors that reflect the body, at the same time as they allude to the smallest building block of life; the tiny organism that forms part of a larger more complex whole, as well as the combination of small experiences, makes up a life.

I'm inspired by playing with scales, moving between the micro and the macro with the aim of discovering the infinite worlds inside of the world in which we live. The world is infinitely deep. There's always a cavern within the cavern; each body no matter how small contains a world within itself.

The Fold is another element that inspires me and that occurs in my work, very close to and influenced by the work of Deleuze.

Rethinking what kind of relationship we have with "nature" today, delving critically and disruptively beyond the romantic idea that we acquired of the concept of nature and immersing myself in the concept of Post-nature, is something that inspires me to explore other places in my life and my work. Orogenesis inspires me. The geological processes through which the earth's crust is deformed and fractured creating folds and refolds caused by powerful compressive forces.

Habitats and architectures created by animals and micro-organisms inspire me. The metamorphic and transformational stages of life. The building of a giant ant hill. The processes of potter wasps. The dung beetle. A river of lava flowing out of a volcano. Mushrooms and parasites that grow in the bark of a tree or on a living thing's skin. Minerals.'

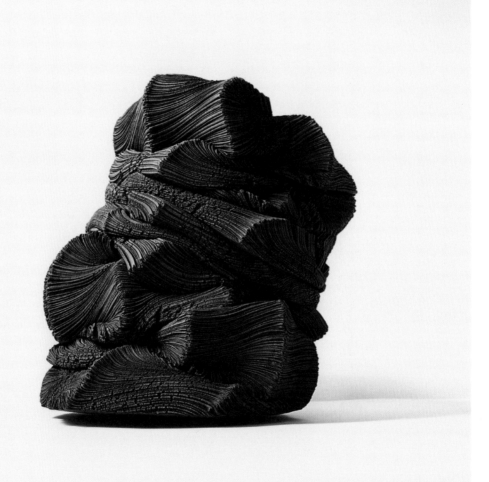

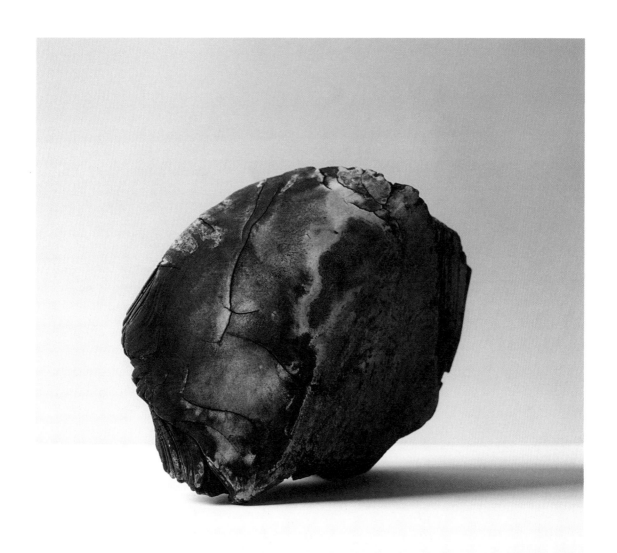

Shozo Michikawa

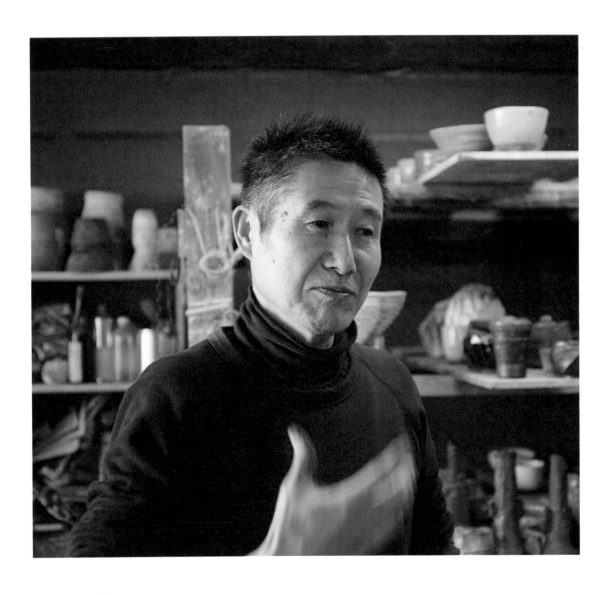

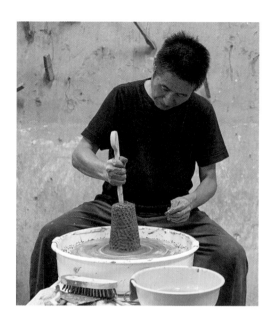

'I hope my work gives people energy. My secret to being a good ceramicist: originality, not imitation.'

'I was born in Hokkaido and graduated from Aoyama Gakuin University. I live in Seto, where I've had my studio since 1980. I've exhibited my work in London, Paris, Milan, Frankfurt, New York, Beijing...

The most important exhibitions and collections I'm working on at the moment include being a finalist for the LOEWE Craft Prize, V&A museum collection, exhibition at Art Basel 2022, TEFAF NY 2022, LACUMA collection, Asian Art Museum of San Francisco.

I'm inspired by nature, forests, cliffs, volcanoes, ancient heritage. When I create a sculpture, I always think about unconventional things.'

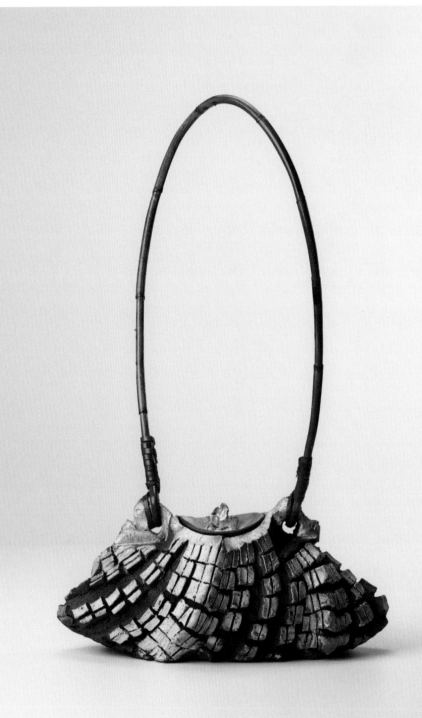

1

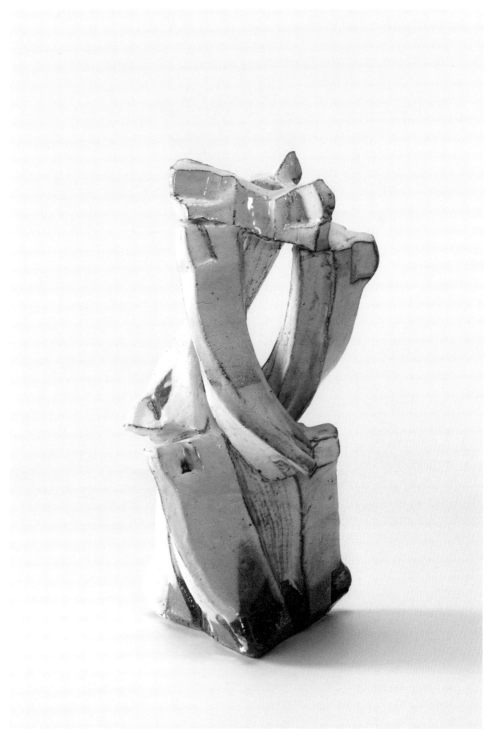

2

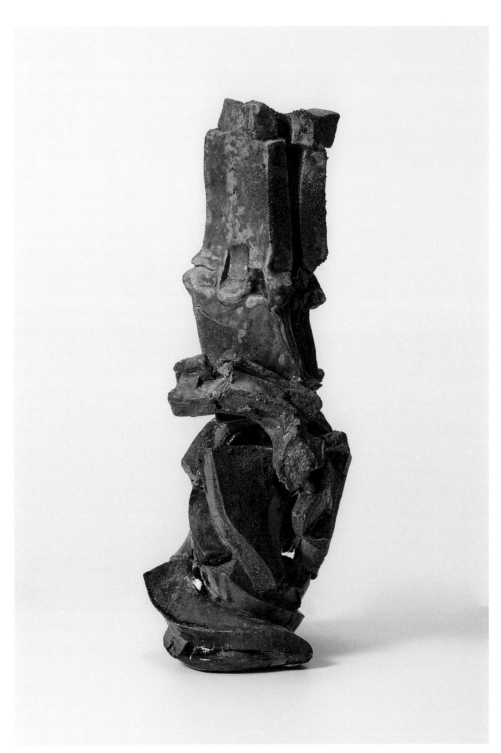

3

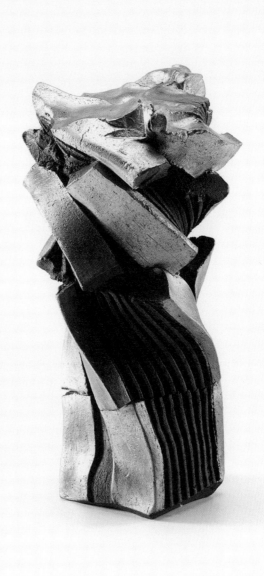

4

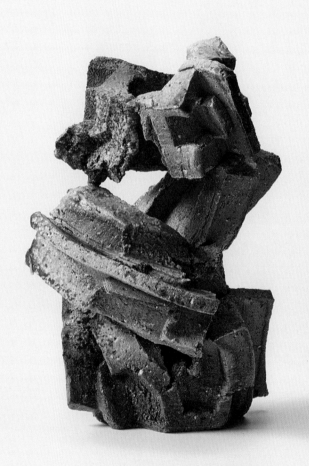

'More than doing ceramics, I have a conversation with the clay. I try to help clear the path the clay wants to follow.'

'The theme of my work is "Nature in art". I grew up at the foot of Mount Usu volcano, in Hokkaido, which is still active. So the mental images of my childhood continue to be reflected in my work.

My faceted and twisted forms are built and sculpted by hand, but, in fact, most of my work is created at the wheel. However, I don't "raise" my pots in the conventional sense. Rather their energy comes from the twisting of the fractured planes on an internal axis. It's a different way of understanding my materials, which has to do with cutting and reduction, instead of the expansion of a ball of clay.

Nature's energy is truly immense. Some of my own creative activities have been inspired by different natural phenomena such as patterns created by the wind in desert sands or a majestic cliff with views of the ocean.

As much as our sciences and our civilisation have evolved, the power of human beings is of little consequence in the face of natural threats such as typhoons, earthquakes, tidal waves and volcanic eruptions. I'm hopeful that when I get something from nature, people can feel and enjoy it, too, when they experience the energy of my work.'

1. *Tanka Silver with Handle.*
2. *Kohiki Sculptual Form.*
3. *Natural Ash Sculptural Form.*
4. *Tanka Silver Sculptural Form.*

Xavier Monsalvatje

Photography: Juan Araque.

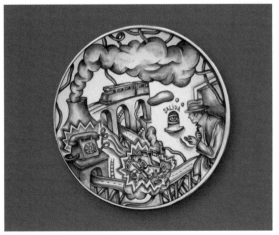

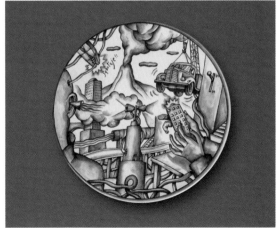

Photography: Javier Ibáñez.

1

2

3

Photography: Scott Seifert

'According to some definitions creativity or ingenuity is the ability to think outside of established parameters, to find new solutions and generate ideas. There is also the idea of the connection between creative genius and different psychological disorders. During Plato's time, the majority of ancient Greeks believed that creativity was divine, a gift from the gods. Plato encouraged poets to embrace the experience of divine inspiration, an experience which he described as leaving the senses behind.

I recall a conversation with my parents in which we were arguing whether or not creativity could be taught or if one is born with this creative quality. Finally, we reached the conclusion that both factors were important, an education focused on the arts and a certain natural ability.'

1. *Sin Agua*, 2009. Earthenware dish. Cobalt blue under cover 1030°C.
2. *Sabotaje*, 2009. Earthenware dish. Cobalt blue under 1030°C cover. Caja de Ahorros Inmaculada Collection.
3. *Another view of Sheboygan city*, 2016. Porcelain stoneware, Black pigment on cover.
 Created in Arts/Industry, residence in the John Kohler Arts Center in Sheboygan, Wisconsin (USA).

'Ceramics is a very broad field that involves many processes of creation, production and lines of research which must be, more or less, controlled and studied. Knowing the different firing processes is fundamental for being able to do good work. For this reason I believe that the secret is there is no secret. It's to try and be rigorous, honest and as sincere as possible in your work. To be consistent in what you do.'

'Ideas can emerge at any time, perhaps from the perception and observation of your own environment. But continuous work is important, constant research concerning the projects you're working on, that is, the study of previous or current historical precedents. Any new idea entails a new process, which in turn creates new approaches, forcing you to make an effort in what is called divergent thinking or constructive imagination.

I think collaborating with artists, artisans, designers and professionals from other areas allows new ideas to converge which enrich your original idea and can provide new paths that you weren't aware of before, opening new avenues of study, sharing as a way to generate ideas.

I don't really have a clear idea of it, and so much has been written about the true nature of inspiration. It can be an image, the fragment of a text, the objects that normally surround me at home and in my studio, a random conversation, contemplating nature... Often a project within a project provides you with a new idea for exploration.'

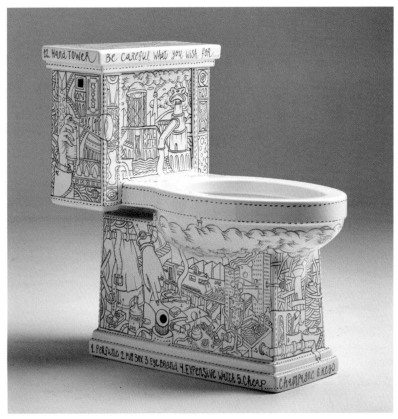

4

Photography: Scott Seifert

5

6

Photography: Javier Ibáñez.

'Although it's important to leave space for improvisation, since sometimes the solution resides in the unexpected, I think that everything is interconnected and it's better to have the idea outlined. I'm not a big fan of last-minute revelations.'

7 Photography: Tato Baeza and Vicente Jiménez.

'Setting new goals that might involve going outside of your comfort zone and separating yourself from procedures that you have already learned helps in coming up with new approaches. One method is to change the way you see your surroundings. A routine causes many things, spaces, places you frequently move through to become something ordinary, uninteresting, and we cease to register the changes that occur in them on a daily basis. Walking along these customary routes with an outsider's gaze, helps preserve the capacity to be surprised, creating the possibility of generating another reflection, and being able to capture the mystery that hadn't been noticed until then.

Play and failure are crucial, First of all, it's essential to keep play alive in the creative process, as it allows us to nurture the imagination, to develop certain skills while at the same time maintaining specific rules, because life is also a game. Nurturing a certain childhood spirit is important.

Contrary to what it may seem, failure can provide us with the solution and frequently augments our responses, not only regarding technical questions but also aesthetic ones. You can learn more from mistakes than from getting it right. But again, to benefit from our mistakes we need to be attentive and open to change.'

Photography: Javier Marina.

4. *Be careful what you wish for*, 2016. Porcelain stoneware toilet, cobalt blue on white glaze.
 Collection Primers Moments de Arte Contemporáneo de la Generalitat Valenciana (Spain).
 Created in Arts/Industry, residence in the John Kohler Arts Center in Sheboygan, Wisconsin (USA).
5. *Casa asegurada*, 2009. Majolica vase with wheel. Cobalt blue under 1030°C cover.
6. *La verdad*, 2010. Majolica vase with wheel, Cobalt blue under 1030°C cover.
 Museo Can Tinturé Collection. Esplugues de Llobregat, (Spain). Potter: Alfonso Alcaide.
7. *Vamos a contar mentiras*, 2013. Majolica vase with wheel, Cobalt blue under 1030°C cover.
 Private collection. Potter: Alfonso Alcaide.
8. *La ciudad del silencio*, 2000. Stoneware, Iron and found objects 1000° C.
9. *La ciudad manipulada*, 2018. Porcelain tile. Museo de Cerámica l'Alcora Collection, Castellón (Spain).

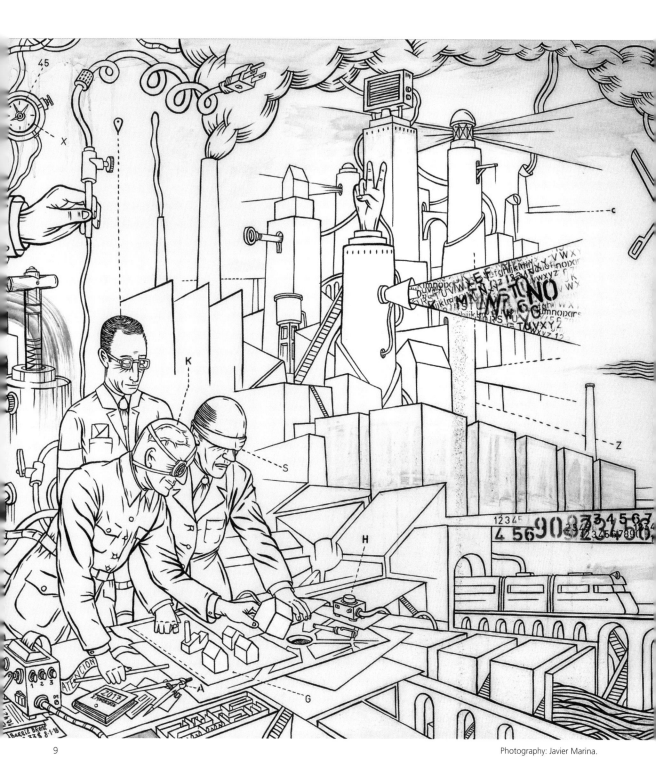

9

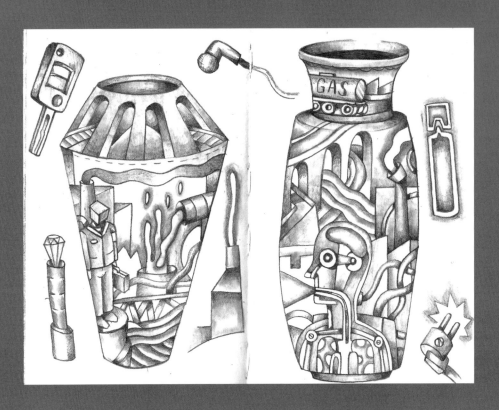

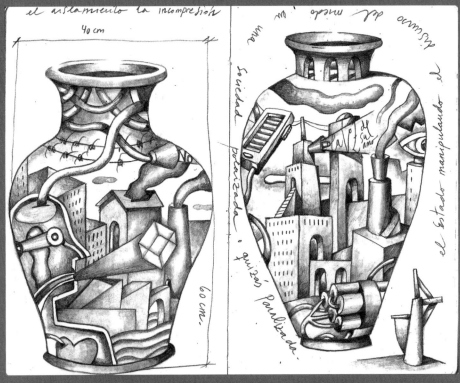

el aislamiento la incompresión

40 cm

una sociedad potenzada, quizás paralizada.

el Estado manipulando el abuso del miedo

60 cm

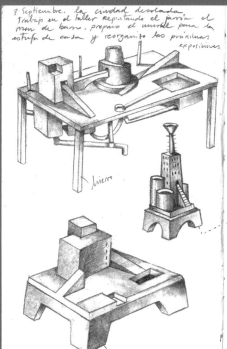

8 Septiembre. la ciudad desolada.
Trabajo en el taller Repintando el jarrón el
mar de barro, preparo el arrabal para la
estufa de casa y reorganizo las próximas
exposiciones.

hierro

la ciudad
del agua

gres

FIRE

nada

X

todo

6

Lauren Nauman

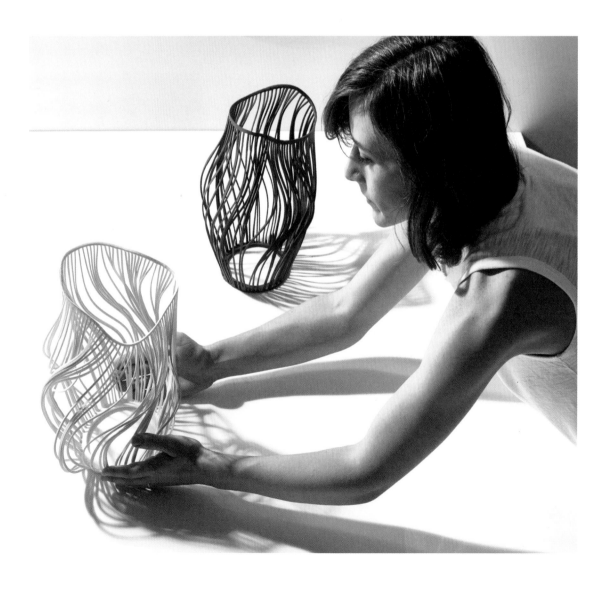

'I believe that my patience and slow moving nature help a lot. I think most successful ceramicists are patient. It's just a little of what the material asks of you.'

'The combination of my love of art, interior design and 3D work led me to craftsmanship. The traditional technique of slip casting is central to my work. I let the plaster mould making process and clay casting influence my designs. While this might seem limiting, I don't always use these methods conventionally. They've simply become tools to materialise my ideas.

For me ceramics is all about trial and error. I don't know if this is true for everyone, but I suspect it is for a lot of ceramicists. I think it's a very difficult material and solving problems is a very important aspect of my work, and according to my experience, this is also true of other ceramicists.

I believe most of us improve when working in spaces shared with other ceramicists, sharing kilns and materials, and also ideas and solutions.

Currently, I'm working on utensils and articles for the home, which has opened up a whole new area of frustration and difficulty that I relish tackling. Although challenges can hinder motivation, I think this is what keeps me interested in continuing to work with clay.'

'The most important aspect of my ideas and my creativity is, in fact, making mistakes or better yet, trying things/implementing ideas. An idea comes to me out of the blue and I write it down or make a sketch on a piece of paper and test it when I have time. I try to set aside days for play.'

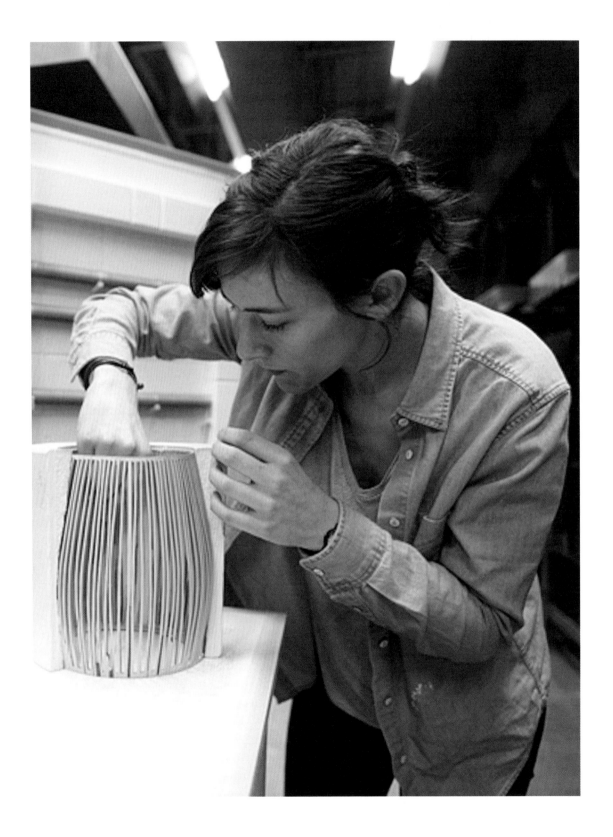

'I find most of my aesthetic inspiration in simple things from daily life. My main interests are architecture, nature and interior design. The personal motivation informing my sculptures is the challenge posed by the pieces themselves. They're difficult to make. So I like to push myself to achieve what's almost impossible with clay.

I consider my designs to be minimalist, but sometimes my work takes on a life of its own and becomes decorative. I'm attracted by such contemporary artists as Hitomi Hosono and Annie Turner, who I think are skilled masters of their craft.

I began working with ceramics as my main material towards the end of my undergraduate studies in 2012. I'm drawn to its versatility, the way it transforms the clay into anything. Clay can be a very frustrating material to work with, but I think this is why I like it. The attention and care it demands creates pride in the final result.

In some pieces I add metal to the work. If a piece breaks or folds in a certain way, I replace or fill the hole with metal wire, usually brass, to save it. It's a 3D game with the Kintsgui concept, the Japanese art of repairing broken ceramic pieces.

While I was a student and assistant, I learned a lot about making moulds and slip casting. The specific technique of dripping the slip in the mould and allowing the pieces to move during the casting process to create my shapes was something I developed during my master's degree at the RCA.

I participated in Guldagergaard Project Network (Denmark), in 2014. It is an international centre for ceramic research.'

'Creating is my life; regardless of the project, I focus on what I'm creating. Things don't always work but I like taking the time needed to create challenging objects. My work explores the limits of clay, and I tend to use experimental processes to achieve my visual objective.'

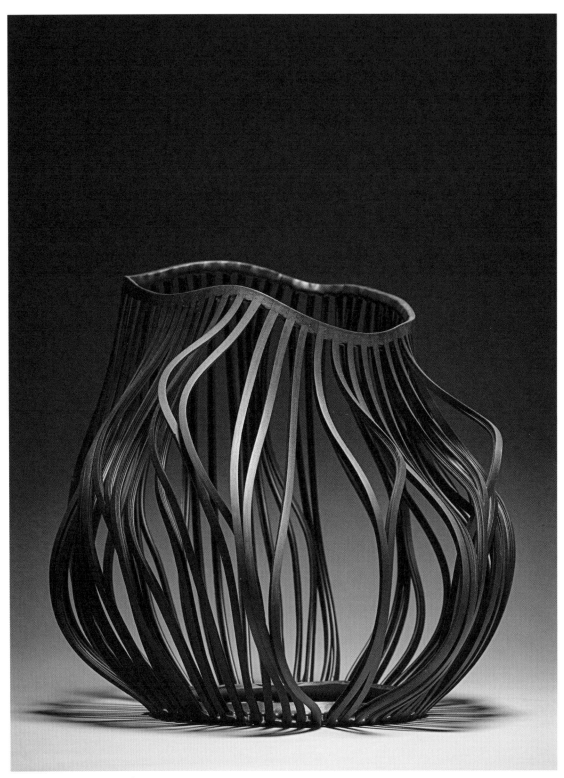

Photography: Christian Baraja Studio.

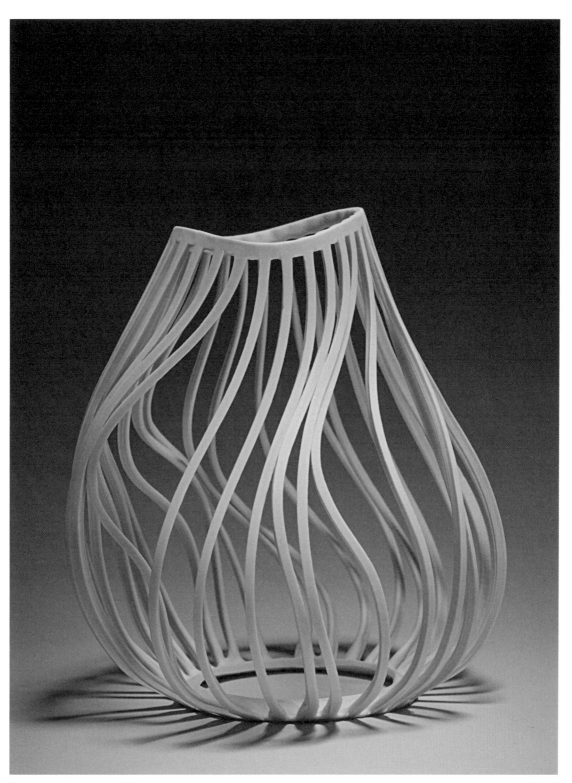

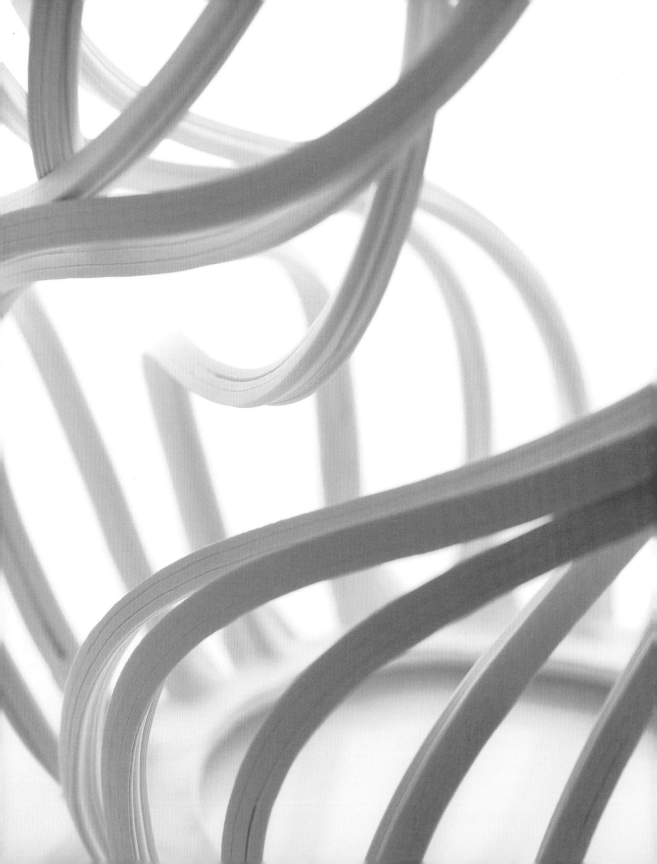

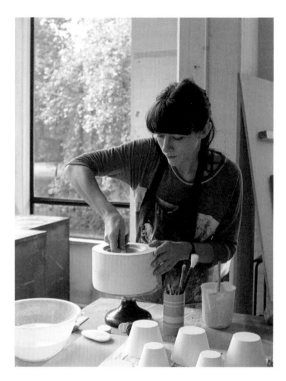

'Producing individual pieces, the drip of the clay, seems very meditative to me.
All my energy is focused on building the piece drip by drip. The therapeutic nature of building something so delicate and then letting it go during the firing process.'

'Porcelain can be more difficult to use, but for me it's what moves best during the firing process and has a pretty raw finish. I started with terracotta because of the intense brick colour I can achieve with it. I leave the clay "naked", without varnish or glaze.

My work isn't obviously ceramic. So I like to leave it as simple as possible to show the raw nature of the material.

My process: I start with the industrial method of making plaster models and moulds. Then, I drip liquid porcelain (slip-casting) into the mould to create a straight cage made of clay. During firing, because of the heat of the kilns and pyroplasticity of the clay, the pieces move like cloth and take on their own form. Due to this process, the final form of each piece emerges from minute details in the production process, but it depends mostly on chance.'

Photography: Sylvain Delen.

Yuko Nishikawa

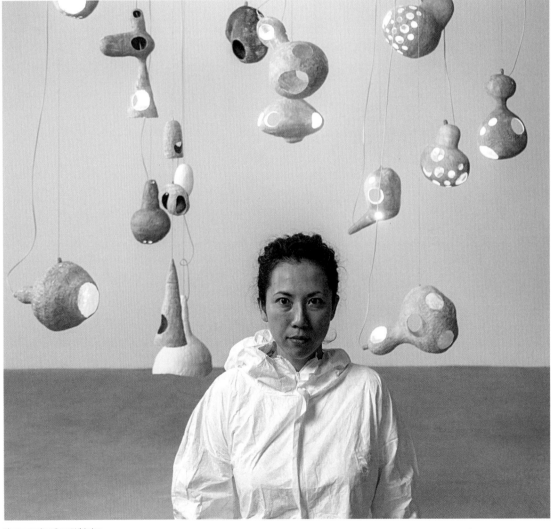

Photography: Cary Whittier.

'For my work, I don't want to have a style. I see it as a routine or a ritual, and I don't want to work out of habit.
There are features, like my handwriting, my voice and the way I walk, which I can't escape even if I wanted to. I see these characteristics as something that pursues me. They follow me, and I don't even know where I got them from.'

'I create fantastical environments with living, colourful and textured shapes. I use a practical and exploratory focus for making paintings, lighting, mobiles and sculptures in a variety of mediums such as clay, wire, fabric and reused materials like recycled paper and lens from old glasses.

My work reflects my accumulated experience in architecture, restoration, interior design and furniture, arts and crafts, and engineering.

I grew up in a small coastal city south of Tokyo (Japan). In 2002 I graduated with a degree in Interior Design from the Fashion Institute of Technology in New York.

When I create ceramic sculptures and lamps, I look for emotions and some of life's meaning in them. I search for what the work of art wants to express: Do they smile? Are they talkative or grumpy? I see forms as facial and body muscles. This might have to do with my Japanese cultural education.

I want my work to live and get old and for its users to use and handle them so that they form part of their lives, and that the piece itself ages and changes with its users. Once the objects are made, they're an entity unto themselves. All living things change, and I want them to be living objects not dead.

My work has evolved and expanded beyond my earlier ceramic sculptures. The most noteworthy examples include a project during the quarantine in which I painted a painting a day for one hundred days, display windows with mobiles and paintings for fifty-two stores worldwide for the French fashion brand Sandro; ceramic lighting and the sculpture installation *Sporarium* in Friends Artspace in Arlington; the pots and plants exhibition *Obscure Plant Club* in Tula House; and the immersive mobile installation *Memory Functions* for The Brooklyn Home Company, both in New York.'

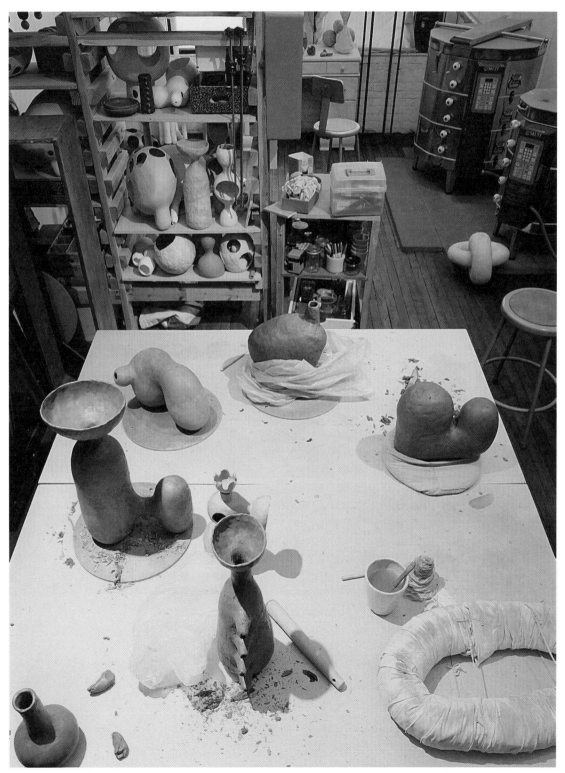

Photography: Cary Whittier.

'I want my work to continue evolving through a sense of play and seriousness and to speak to people's feelings and emotions. I'm interested in our mysterious side, nature and the animal aspect of humans that we aren't able to explain. This is why I create works of art.

I don't look for inspiration. Ideas are abundant. For me, it's a question of what ideas to focus on and pursue at a given time. I look for ideas that excite me and which I think would be exciting for others to experience in a specific space and time.

It seems to me that ideas appear when my body is in motion, such as walking or moving my hands when drawing or making things. They don't seem to come to me when I'm sitting. In the studio I like to work standing up. This isn't limited to ideas for creative projects. From exhibitions to building things, I also do a lot of planning. I draw diagrams and sketches to process my ideas, my thoughts. They aren't lists or reminders. I process my thoughts better through the act of drawing.

It seems too much attention is paid to not doing a bad job or making mistakes, even before doing anything. For me this isn't an important concern if I can create respecting the materials and others.

I see my work as a connected project, a whole. So it's impossible to choose a piece and say this a good piece of work, this is a bad one, and this one was a mistake. I'm not worried about the "success" of the individual pieces. What's important for me is that my work as a whole evolves and develops. I like to see personalities in works of art, that is, not the personality of the creator but of the work itself. The work can be happy, in a bad mood, nostalgic, angry, talkative or fun. I would like to perceive something.'

'I think a good ceramicist must be capable of feeling and then expressing how they experience their daily life. Limited abilities, mental and emotional state and health could complicate their feelings and expressions. So the secret to being a good ceramicist, I think, is staying in good physical, emotional and mental shape, and to be constantly acquiring skills.'

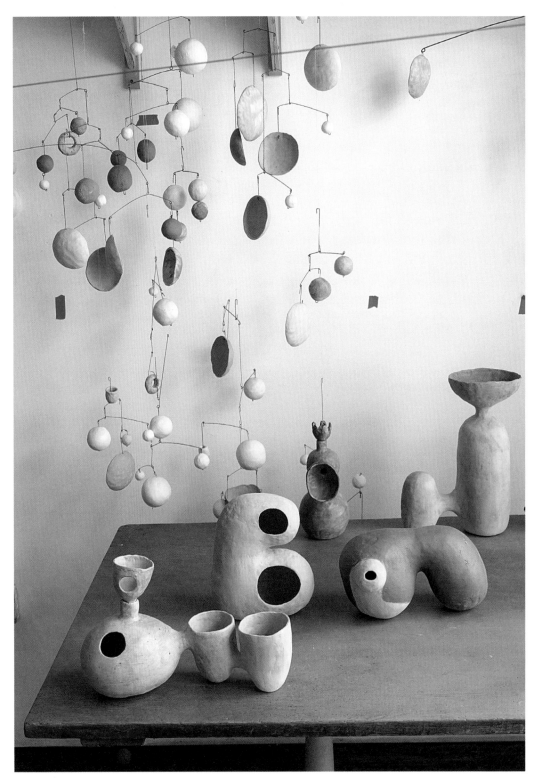

Photography: Yuko Nishikawa.

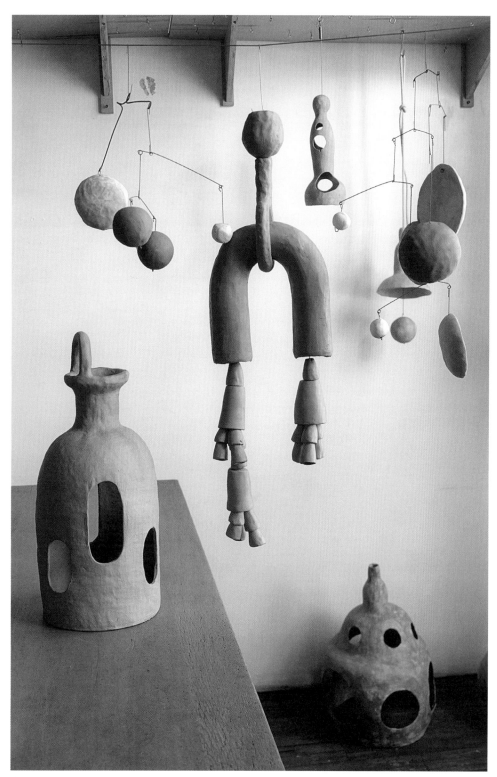

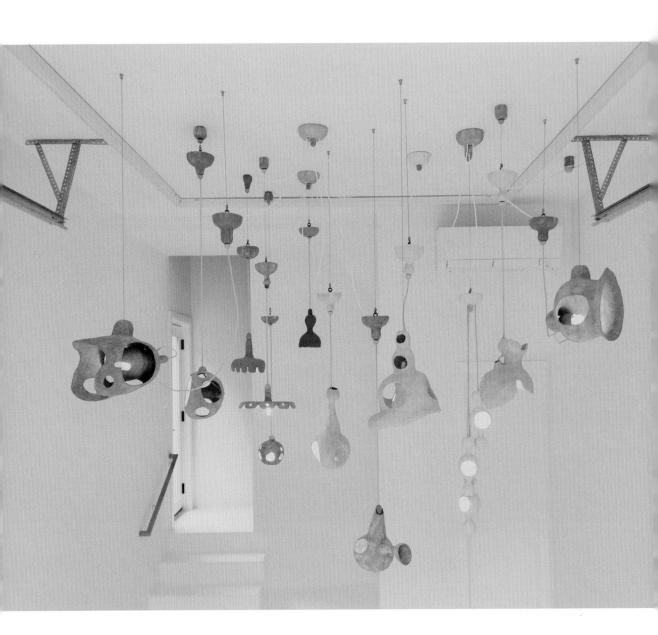

Photography: Ethan Hickerson.

Nuala O'Donovan

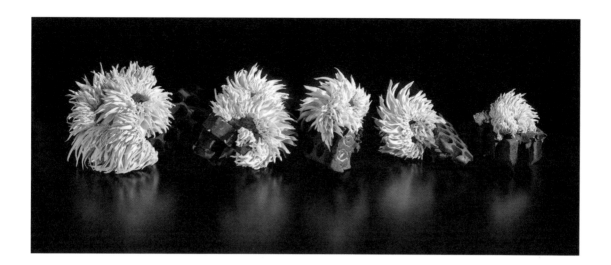

'I create sculptural pieces in porcelain clay. The work is based on the patterns and geometries of natural forms. My research into the irregularities of these patterns explains the way the work is constructed. I use a combination of classical and fractal geometry when deciding on the size and proportion of the finished work. My interest in the patterns of natural forms lies in the narratives embodied in the scars, aberrations and imperfections that signal an event, a history, a life lived.

I like to work with clay, but I'm interested in all materials. Clay is a material with the same possibilities for interpretation as paint, stone or wood; for me the material is a means to an end. I'm against the way artists are always classified by the material they use. Each material has its own possibilities; I think each creator must find their own relationship with it. The artist might challenge the material, or the material might challenge the artist, but I think the artist must be clear on where they stand in relation to the material.

I use clay because I've discovered it's the best material to create the work that interests me. I find exciting the unpredictable results of the effect of the production and firing process in new structures, especially the firing process that can transform a piece. I like the challenge of finding techniques that subvert the process by using the behaviour of the clay to influence the result, overcoming in a way the clay itself!'

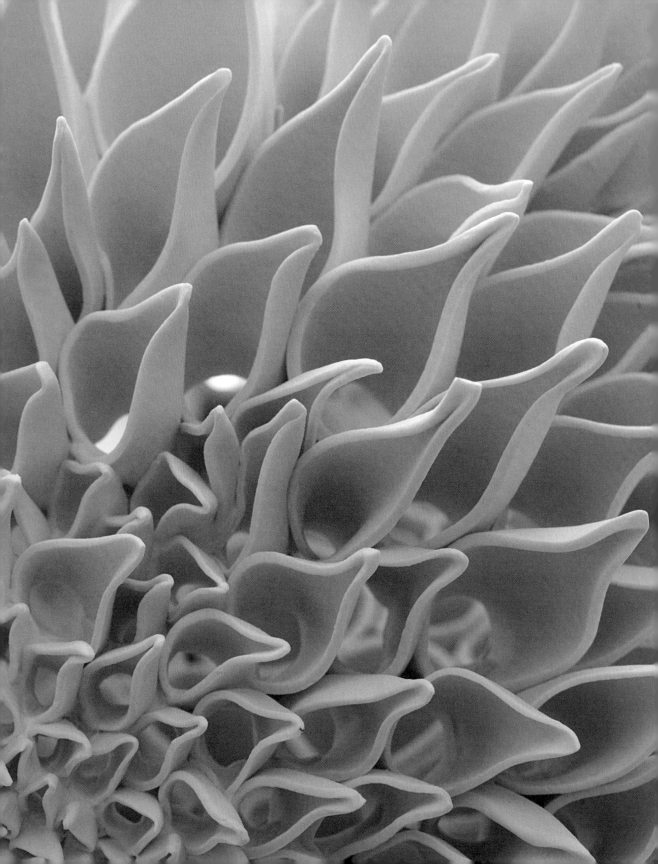

'I've had the privilege of exhibiting my work alongside other artists whose work I've admired for years and in some incredible places. I love to travel. Sometimes the opportunity to continue my work has given me the chance to have a relationship with other people, communities, museums, curators and artists from a lot of places. I very much enjoy this connection: it's almost like a global community that celebrates universal experiences and points we have in common.

That said... There's nothing like having a show in my home town! The exhibition that grabbed my attention most was the one at the Crawford Municipal Gallery, in the city where I was born, Cork, Ireland. The gallery is in a historic building that I visited when I was a girl, often to see the work of my great uncle which formed part of the permanent collection. He was a painter who studied in London and Madrid in the early 20th century. When my work was acquired for the National Gallery of Ireland and exhibited in the same galleries, it was the most incredible feeling, almost like completing a circle.

Another high point was having my work included in the exhibition "The best of Europe" at the first Homo Faber event in Venice in 2018. It was an amazing experience to be a part of, celebrating the best in design, tradition, passion and innovation in Europe.'

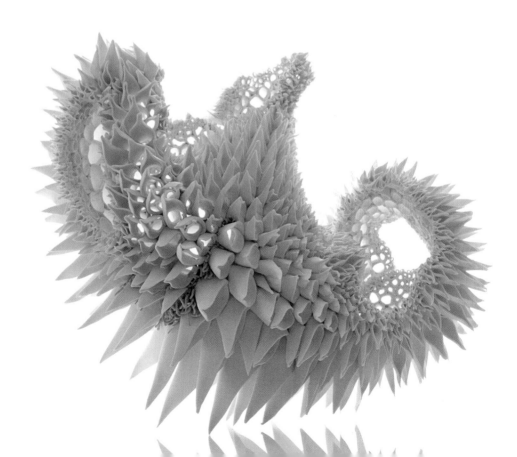

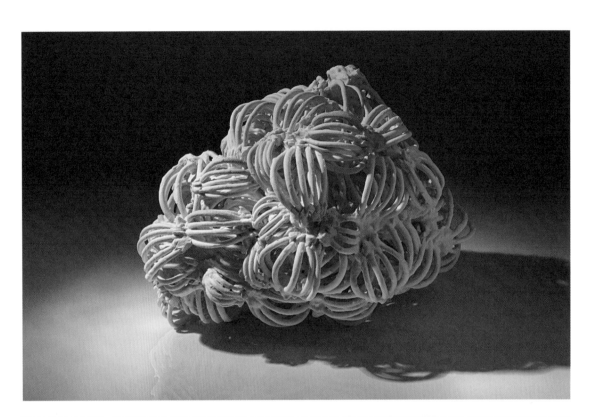
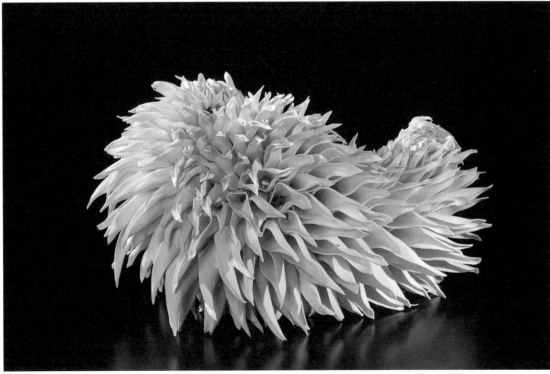

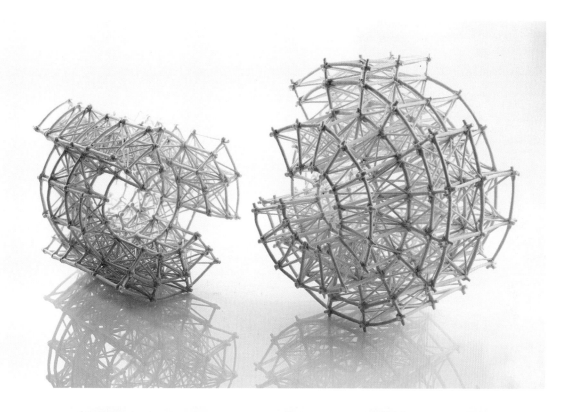

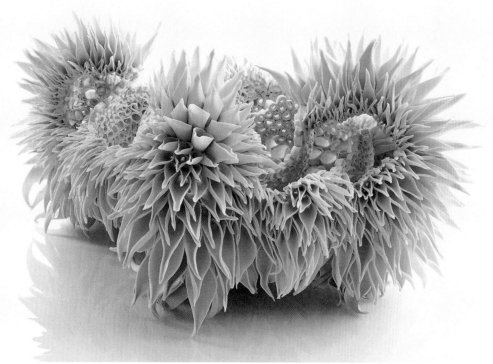

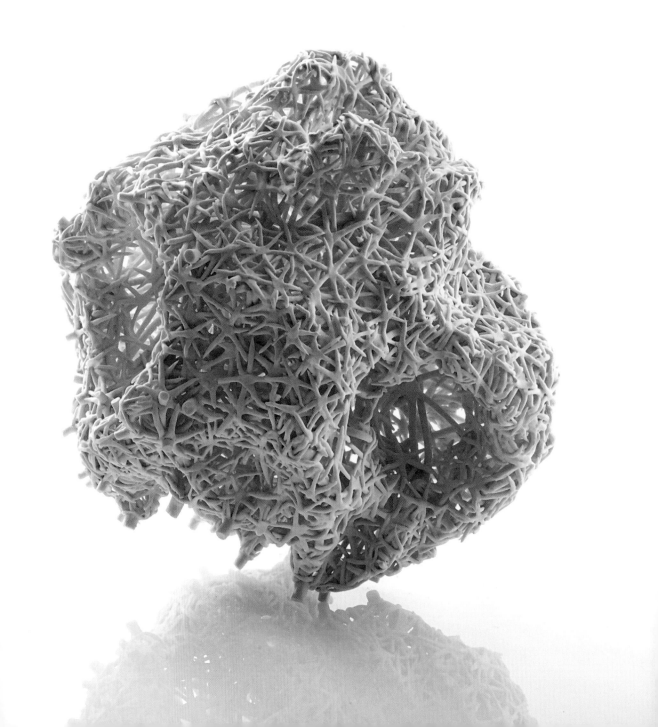

'Like in any activity, I think that whoever loves their work will be good at it. Working long hours, nights and weekends also helps.'

'What I've learned the most about the way clay behaves has been with pieces that have failed, that is, ones that refused to meet my expectations. I really like the learning process. When I've completed a piece, I don't want to repeat it if I think it's a success, because this is the end point for me. So I always see some aspect of the work that hasn't met its potential and I want to create another piece that corrects the mistake. Every piece forms part of a series that explains the next step in the work. If I don't find a new or interesting direction to explore, I stop working on the series and move on to a new one.

I think fear is the main cause of creative blocks; I only have them if I'm doing a commissioned work, for someone else, and I worry it's not going to meet their expectations. In general, when I work for myself, I want to try out an idea and see the result. In this way, the work can be good or bad, but it will be interesting because it's an exploration of an idea without expectations.

If I see that I'm afraid to do a job, then I start others that are familiar to me and I can do without thinking too much. I think it's the best way to stimulate new ideas and directions. Once I start to draw, I'm aching to try different three-dimensional versions on paper, cloth or clay, whatever I have at hand. From there, the work unfolds. Being open to new directions has always worked for me.

I think making mistakes is the best thing you can do, both in art and in life. Mistakes tell you where the breaking point is. They show the artist how far they can take an idea or a material. Sometimes the results are more interesting, and always infinitely more educational, than "success".'

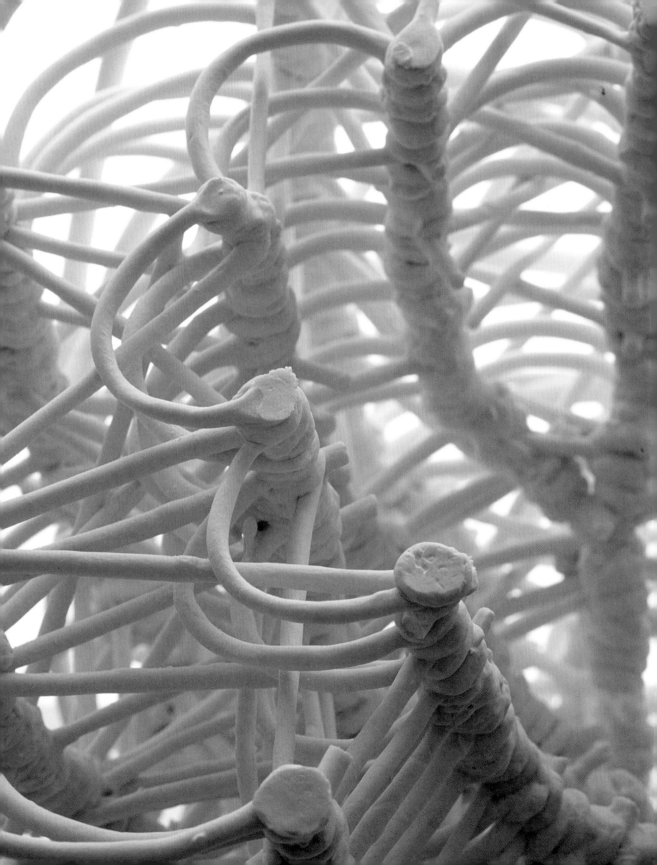

'I want the work to allow the observer to become an artist, so that they participate in the exploration of the future possibilities that resolved but unfinished forms leave open.'

'I begin my sculptural pieces by observing the structural patterns found in nature. The work begins with photographs and drawings of natural forms. The drawing requires meticulous observation, and I'm always intrigued by the details, especially irregularities in the patterns. They suggest a history, an event in the life of an organism. Structures also interest me.

Isolating a single element of the three-dimensional pattern, I can study the way the structure of the plant is created and use this information to begin to construct a new form. The plants I study tend to be examples of regular geometry, whose principles constitute the foundation of classical art, which sought to represent beauty through a harmonious form based on symmetry and proportion. In my work I combine both geometries: classic/regular in decisions regarding the proportions of the work and fractal/irregular in constructing the piece.

The possibility of infinite repetition of the fractal form creates another important aspect of my work: that of infinite and open possibilities. I've always been more excited by the explorations and beginnings of the work than the finished piece; to avoid being disappointed, I try to create pieces that are resolved but unfinished. The incomplete form preserves the possibility of multiple results: It's a story in the process of being told. I start the story, I create the intrinsic design, and I leave space where each observer contributes their experiences to imagine a unique and personal result.'

María Oriza

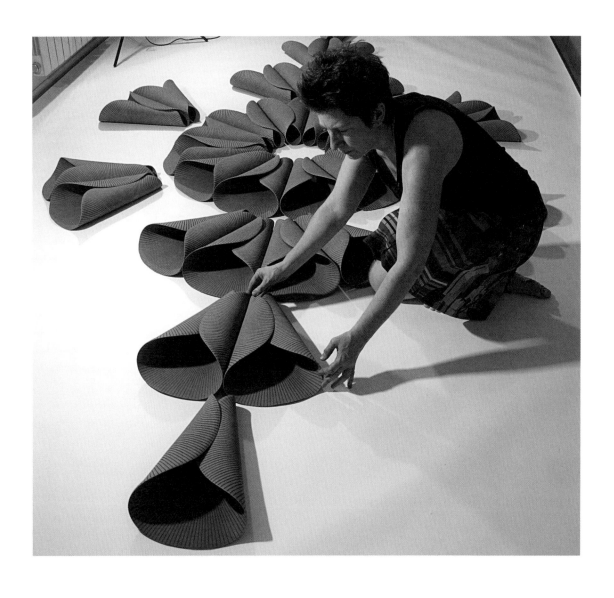

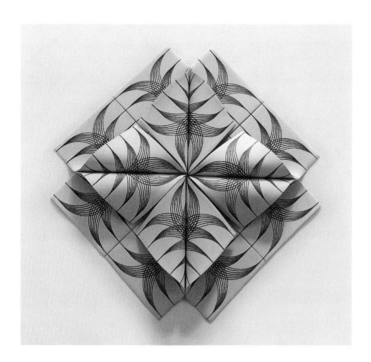

'When I finished my ceramics school training, I had the feeling of not knowing where to continue. I remember tons of pieces made during those student years and also later, when I felt like I wasn't producing anything that truly represented me. Now, I see that time as a blind search without a definite direction in which I simply wasn't able to create a true connection with what I wanted to say. However, I'm certain that during that period the foundation of who I am today was established in some way, and without a doubt it showed me where I didn't want to go. The work from that time lingers in my memory like an amorphous and indefinite sound that I wanted to distance myself from. At some point, I felt the need to physically divest myself of all those pieces, and I decided to bury them. It was an exercise in purification.

As I progressed in my career, I kept imposing the rule on myself of trying not to do anything that reminded me directly of somebody else's work. To follow a path off the beaten track, and even assume as mine own an aesthetics that wasn't part of the plan I'd originally conceived for myself.

I was interested in exploring and surprising myself with the results of what I'd made, to observe what I'd done as if it were created by someone else. Slowly, I began to recognise myself in my work, like looking into a mirror that reflects the parts of yourself that sometimes you don't even know. Little by little, the work became capable of conquering the space it occupied more easily, as if it merited the right to remain in the world to accompany, and to be observed and shared.'

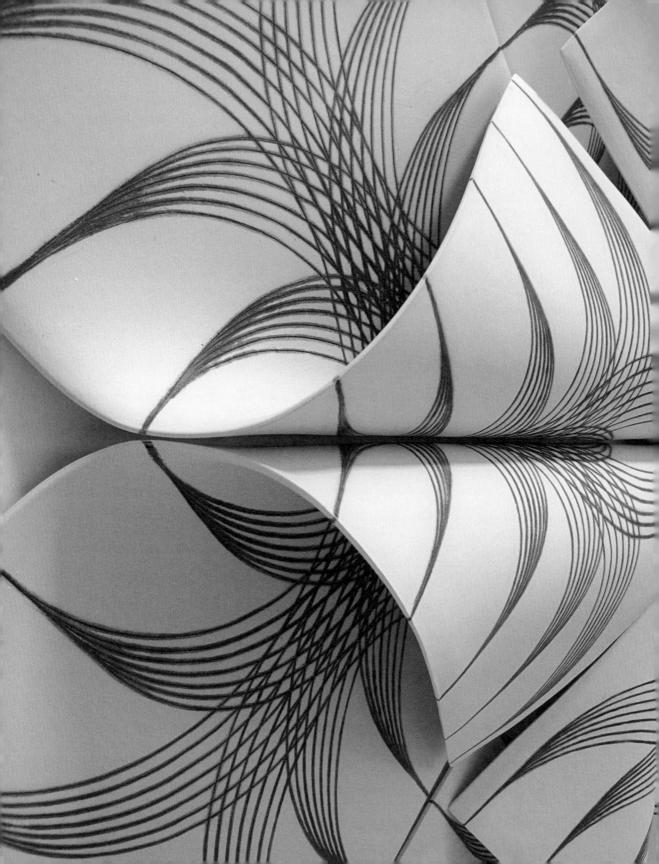

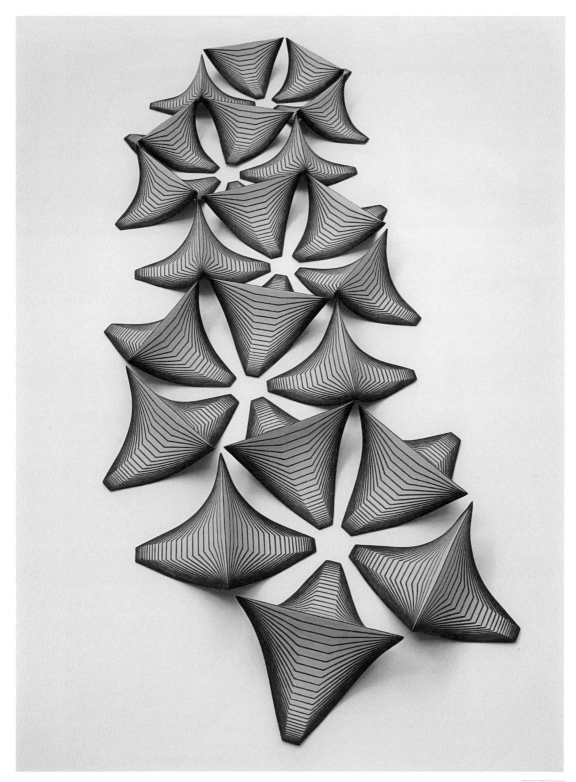

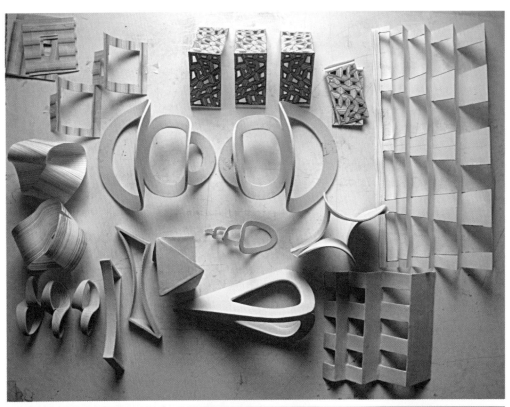

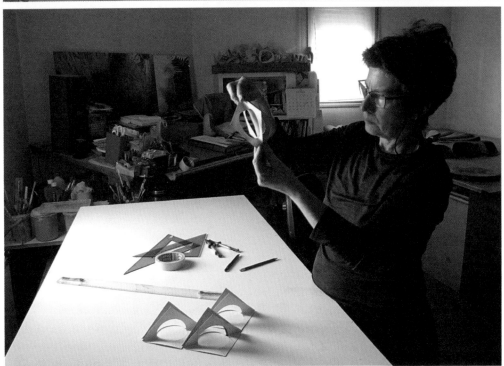

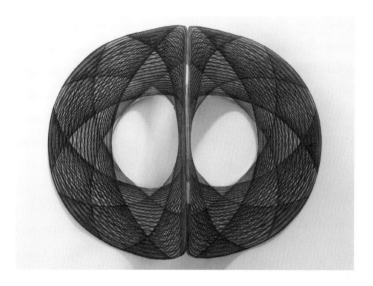

'In the perception of our surroundings we can observe thousands of categories that can serve as a point of creative departure: to empty, to fill, to balance, to assemble, to articulate, to associate, to repeat, to crease, to flow, to fold, to support, to tighten, to move towards, to move away from, to contrast, to thicken, to puncture. Everything can be made into a story.'

'Reflecting on what one does, why one does it and how one does it is a complex task. What one does is in sight; in my case they're tangible objects whose experience in their creation I store in my memory. A slight memory of how the idea came into being, a fixed image at a specific time, sensations in which uncertainty about the result mixes with the memory of the effort, the joy or disappointment over the result... It all accumulates in the form of layers on top of which new ideas settle down. At the same time, they represent my personal warehouse of detonators to set off in the future.

The source of inspiration is a subterranean current, not very clear or obvious, hard to verbalise and impossible to hold back. These are moments of clarity in which dreaminess about something that doesn't exist is mixed with the determination needed to overcome this limbo and make it a reality.'

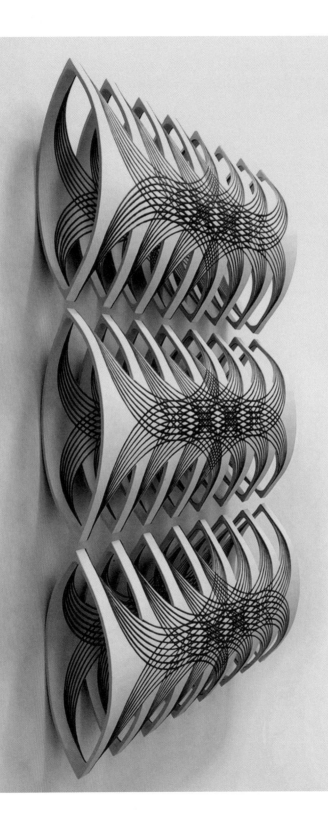

'Over the years, I've chosen different work methods until finding where I'm most comfortable and where ideas occur to me more naturally. In my case, a paper mockup is an essential tool. An important part of the project's potential is revealed in it. The composition, distribution, proportion, drawing of the surface... Later, if it's necessary, I make stoneware mockups, which will be the definitive material. At this point, I decide how thick the different parts of the module will be. I sense what degree of humidity will be needed and I anticipate what the strategy will be to assemble the piece; where there will be junctures, where tension could arise, how I will fire the piece without deforming it... I try to imagine each and every problem that could arise and have a solution prepared for it.

The work process itself is inspiring. During it, certain ideas link up with others like on an evolutionary scale, and I feel like I'm blazing new trails. What we do is the product of who we are in connection with the material we use to tell it. The material becomes a vehicle for thought, but you also think in terms of the material you use and a specific way of doing things. You assert yourself according to its parameters. We are mutual determinants. As you advance, you gradually strike a balance between self-criticism and indulgence.

I'm sure if I used another material, I'd discover another part of myself. Other ideas would materialise and today I'd have a different story to tell. Some materials like clay are so versatile they let you discover your own paths. At first the search was inevitably superficial, and I focused on having a general vision of the technical and aesthetic possibilities I was capable of developing. Yet, gradually I began to specialise. I was delving deep and discovering new possibilities that began to appear in consistent work in which I saw a common thread. Each work appears like the chapters in a book.

To achieve the necessary symbiosis with the material contributes to mastery of the technique. There shouldn't be anything mechanical or routine in the studio, and everything can represent an evolution if you're sufficiently alert. The limits that you know expand and any change, no matter how insignificant, has consequences. Making the most of mistakes and anticipating things are lessons that I always keep in mind.'

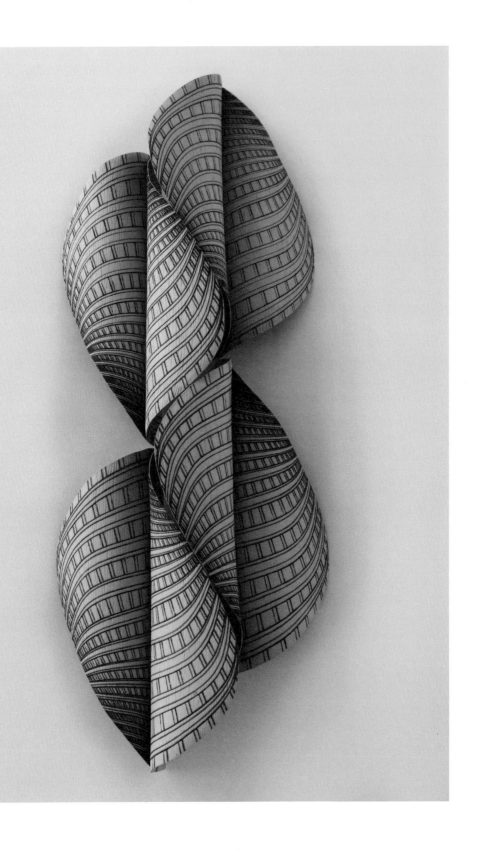

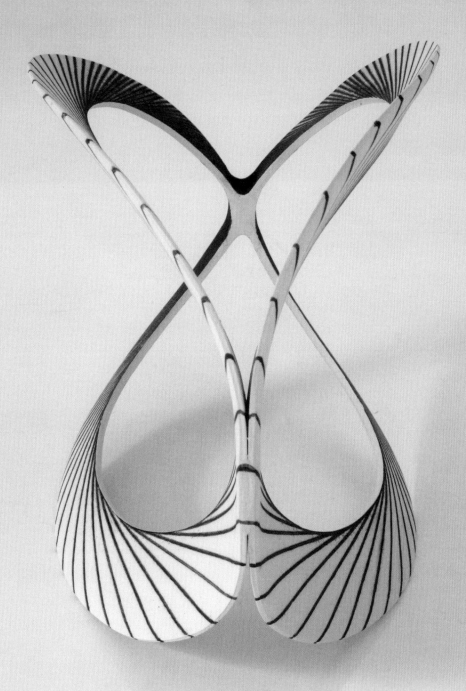

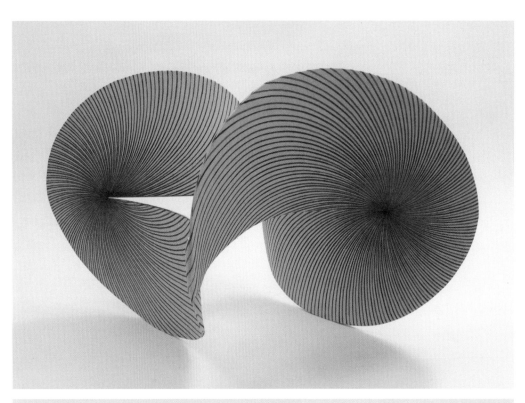

'What I usually want to communicate is abstract and scattered. The departure point is observation of myself and my surroundings. Discovering my natural tendencies is important to avoid a continuous struggle with myself in the studio. I observe where my vision tends to go and what triggers the appearance of interesting images to embody in the work. When I decide to start a project, for me it's important to be convinced that what I've planned deserves all the effort, time and energy needed to make it, needless to say, regardless of the result.

My work consists of transferring to the clay fleeting moments of clarity in which images appear that can take on form. Sadly, they're indefinite images that tend to lose all their charm when they're transferred to the material; as if a spell had been broken. For this reason, it's necessary to develop the intuition that tells you where there are and where there are not possibilities, to be capable of, starting with something minimal, visualising the potential which it can have. Basically, it's an exercise in faith and thinking that this small insignificant mockup contains the seed needed to become a work of art.

Once the idea is revealed and materialised in the mockup, it's a question of analysing what the key points are that grant uniqueness to the work, and exalting them. I try to strengthen these arguments with all the resources I have within my reach, until I find the consistency that imbues a material object with meaning. For this, you have to corral all the elements in the same direction and remove the visual or conceptual contradictions that neutralise the message. There's a fine line that separates what works and what doesn't, what's attractive about indifference. It's hard to analyse the magnetism of an object when we find ourselves in the realm of emotion and subjectivity. In the end, the only thing we have left is to trust our intuition and, if we feel like it works, hope that others also pick up on it.'

'You have to have the modesty in every piece to enhance something seemingly insignificant and put it on centre stage; to dignify the beauty of the simple, to give prominence to the gesture of the material, a simple twist, a curve, a hole.'

Paola Paronetto

Photography: Clap Collective.

'Everything I do is an expression of who I am; what I feel and what I love are embodied in ceramics.'

'After many years working and experimenting with traditional clay techniques, I decided to completely abandon the conventional approach and create more innovative and dynamic forms: the Cartocci. For this, I chose paper clay, a flexible and revolutionary medium that allowed me to express myself, pursuing my imagination, free of stereotypes and in harmony with my most intimate feelings.

The forms and textures are fluid, not rigid and transmit the feeling of movement. "Imperfections" are embraced as something that provides character and authenticity, and each piece forms part of a family of objects as I rarely stand them alone.

The most special collection for me is the *Bottles Collection*. They were my first creation using paper clay, and I feel a real affinity with them.

I am very busy with my work and have very little time for other interests but I love spending time with my family, in whatever form that may take and when I have some quiet time for me I lose myself in a book.'

'Mistakes are always interesting. When we make them, they always have a price, but then, they spur you on to improve and learn. Sometimes, pleasant and unexpected surprises arise from mistakes.'

'Creativity and being creative is not a conscious thought process for me. It's just how I feel, what I experience, what I see and then what I feel like doing. It's very spontaneous. Since as long as I can remember, this is me. I've never had to search for ideas. I express what I see and what I feel: it's something natural.

I'm inspired by nature and human connections: I see ceramics as animated objects, entities that dialogue with each other, just as in nature and between people.

Ideas come; I have never had to look for them. I have a thought or a feeling and I will perhaps draw something and come back to it at another time. I have a book full of unrealised creations which I look at from time to time. When I have a problem or challenge in realising a specific piece that I'm working on, I keep working until I overcome it. I don't give up. There's always a way. Creative blocks are something I've never experienced. I realise there are periods when I'm "less creative", but it's always because I'm so busy with daily life and don't have a lot of time, but once I'm able to focus on my work again, I pick up where I left off.'

'The secret to being a good ceramicist is passion, curiosity and the determination to overcome obstacles you encounter along the way.'

Monika Patuszynska

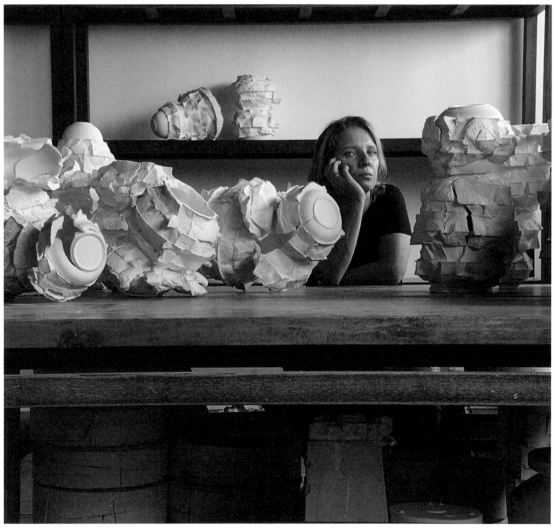

Self-portrait, 2017.

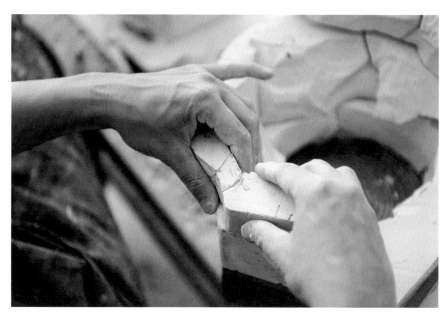

Photography: Grzegorz Stadnik

'I make non-functional vessels. A form of vessel is abstract and personal at the same time. In a very discreet way, they contain their own history and the history of the relationship with humans. My favourite material is porcelain, because it's uncontainable and, like me, it likes to follow its own path.

For years I've been casting the way it's supposed to be done, repeating the gestures of thousands of people who were casting before I was. However, the limitations of "adequate" casting always seemed to me too narrow. There was a time when the list of "what one shouldn't do" became for me a guide through ceramics: the list of "what needs to be done".

I tend not to believe in anything I don't experience myself, especially superstitions related to use of the materials. Luckily, I'm not in a situation where I have to produce on a massive scale, and I make the best of all the advantages that a ceramic studio offers. The plaster mould isn't a final product; it's only the beginning of the creative process. I've cast without the mould; I've created moulds without having to make the model first.

I prefer to treat the material as a companion, not a rival when working in my studio. I don't try to repress it. I consider myself an explorer and a thinker, as well as a maker.'

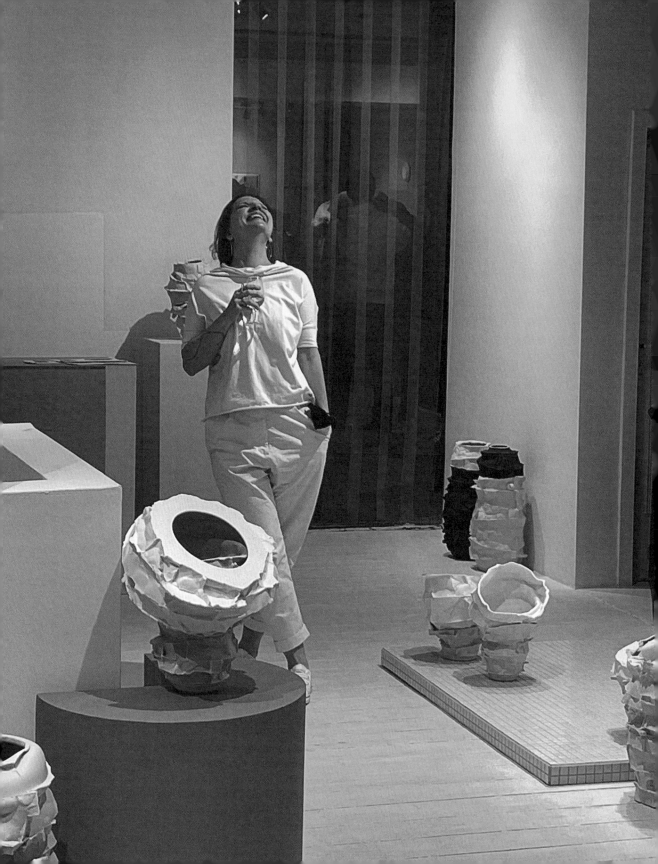

'My creative process always begins with the thought of trying to imagine what would happen if... The next step is to try it. Ideas come from chasing accidents, from exploring them and questioning everything.'

'For me "imagining is remembering". I think the new creations that emerge are *collages* of what we know, of what we've already seen or experienced, elements that each person arranges in their own way. They're like the letters of the alphabet, even though we all use the same whole, the number of word combinations, poems and novels that can be created is infinite.

My main inspiration is my own work and the nature of the materials I work with. I'm inspired by the process, especially all the mistakes and accidents. I'm constantly searching for the difficulties involved in working with porcelain. The objects in themselves aren't the main objective; they're a secondary effect of my explorations.

I don't pursue ideas. Rather I let them come and grow. Casting consists mainly of waiting. After pouring the casting slip into the mould, you can't speed up or slow down anything. The only thing you can do is give yourself over to the rhythm of the process. Fortunately, the waiting entails thinking. Sometimes, when I wonder what the proportions are, it seems like my work is based on thinking as much as it is on working with my hands.'

'I like to invent problems in my work, formal riddles that I can solve later. I'm also driven by curiosity, for example, what the inside of a destroyed plaster block would be like after being emptied, or how far the limits of emptiness can be pushed.'

Das Gelbe Zimmer, 2022. Photography: Tomasz Balcerzak

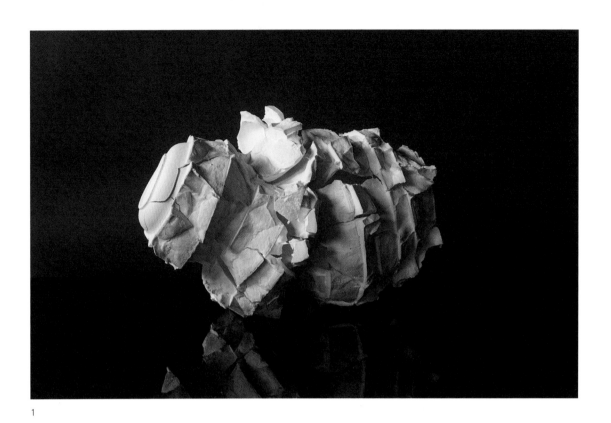

1

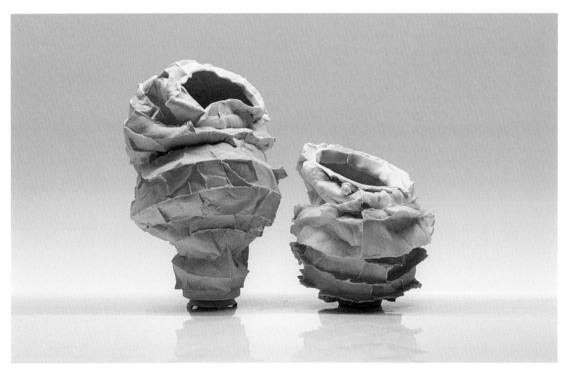

2

'You must not fake what you do, and you need to question everything all the time. Leave the computing to the calculators.'

'Creative blocks are a natural phase of the creative process and of life. I try not to try overcoming them. I don't think about them when they appear. To create is such an incredible process that it always occurs in the depths of your mind, even when you don't intend it. Travelling inspires me a lot. It takes me off the beaten path that a brain accustomed to daily habits would otherwise travel. And it's on my travels when new projects are born that later I can develop when I'm back in my studio.

I like to play with the nature of accidents and work with them. In our culture an accident is considered a fault. Yet, a tamed accident is no longer an accident, right? A tamed accident becomes a technique. I'm an accident tamer.

I've always tried to forget about superstitions and resist superficial notions about what's valuable and what isn't... and what's a failure and what's a success. I'm fascinated by the accidents and errors that appear in the process. I'm also driven by challenges. I try not to worry that it might turn out bad. Normally, I face the next challenge that I invent for myself, and I observe the direction the project is moving in.

The best part of the process is trying. Ceramics combines all kinds of activities: thinking, analysing, experimenting and also physical effort.

For me, it's far more important to cooperate with the elements than to try to subordinate them. This cooperation is only possible through deep knowledge of them. Direct contact with the medium is essential, since ceramics consists of the balance between maintaining control and letting go in an attempt to capture the true nature of the material.'

1. Series *Debris (Shangyu stories)*, 2016. Photography: Monika Patuszynska.
2. Series *Genealogy (on adjusting)*, 2019. Photography: Monika Patuszynska.

APR 2022

maluchy z tytytkami
- hand size, grupa

* wax acels?

APR 2022

bliźniaki
montowane mam

mocny turkus?
+ czerń?
kobalt + angoba?

FEB 21

różne masy, bielido.
we formy

JUN 21

wtarcione elementy
z koła - masa
niżej topliwa
sandwich
w percola
nie

30 - 40 ca
max

Photography: Monika Patuszynska.

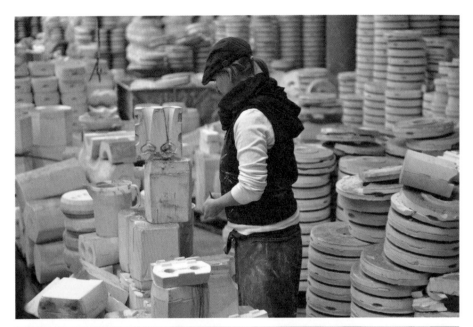

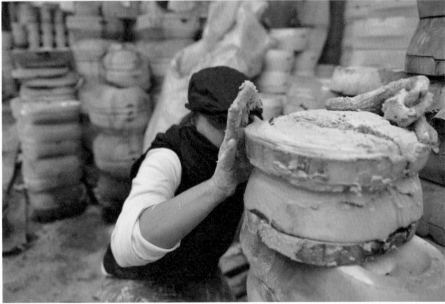

Bastards & Orphans, 2012. Photography: Grzegorz Stadnik.

'From time to time there is a project that haunts and occupies my life and my thoughts for longer periods. Such was *Bastards & Orphans*, a project that involved casting the abandoned moulds straight at the abandoned European ceramic factory sites in an attempt to understand what was left in both the material and intellectual sense there.

Bastards & Orphans was a project created by the last survivor of a fallen civilization because that was how I felt at the time. It was all about the end of the world that I belonged to, which I knew and with which I identified, it was a record of the process of becoming a part without its whole, *pars sine toto*. It focused most acutely on the material remains of loss, appropriating that loss so entirely for me that there was hardly any space left for anybody else. So I began a new project about people and their stories; they are at the centre of *Genealogy* and it concerns them first and foremost.

The *Genealogy* project is about different types of relationships translated into the language of materials. It is a story about combining similar and not similar, matching and mismatching transferred to objects, a project about combining different aesthetic, material, technological or cultural DNAs; about adjusting, about mismatching and the difficult art of maintaining a balance.'

Gustavo Pérez

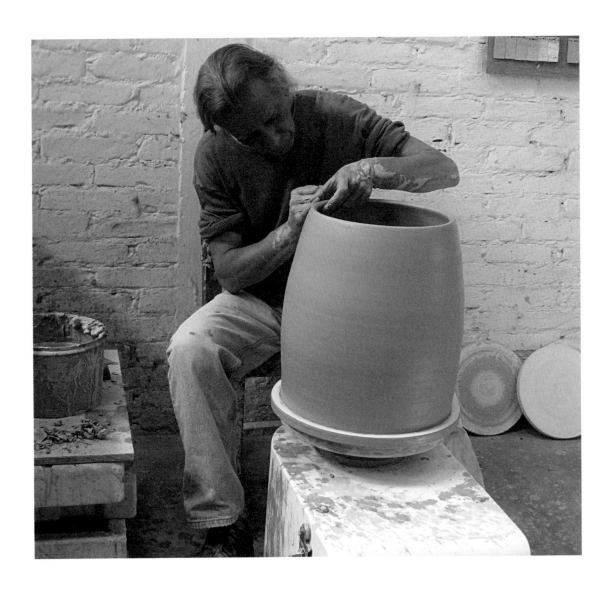

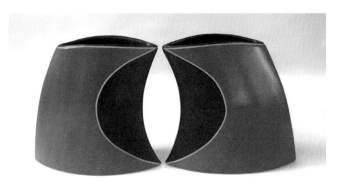

'My work is a dialogue with the clay. After fifty years, I think that's the best definition I can give of what I do. A dialogue in which in addition to curiosity about what could appear, there's something difficult to explain, fascination, passion. In any case, a strong impulse that I don't know how to put into words.'

'The most important factor that differentiates my work from that of other ceramicists is the fact that I had to learn so many things practically on my own. I had the need (or good fortune) to invent or discover my path in technical terms. Without having set out to do so, I know that I was interested in many non-traditional ways of handling clay, which are still considered transgressive in some circles or prohibited by the canon, but they brought me good results, ones that match my sensibility, my vision. And not being part of any school or tradition, they've worked as a distinctive, original stamp.

I've always worked very systematically, devoting my attention to a specific topic for an amount of time that has varied a lot. Sometimes the topic needed years of work, other times a few months, and there have even been very brief projects of two or three days.

My most important exhibitions are the Museum of Modern Art (1999) and the Bellas Artes (2011) show in Mexico City. Also the one that resulted from my work on Manufacture de Sèvres (2010). Yet, without a doubt the most important and ambitious one was the show I had at the Museo de Antropología de Xalapa, Veracruz, a large installation with some five thousand pieces.'

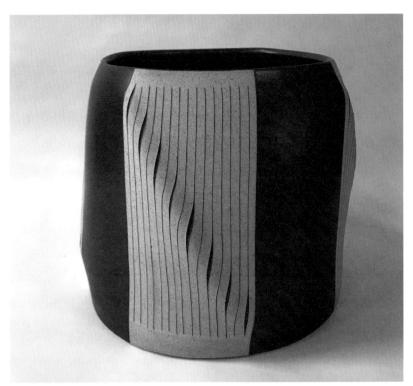

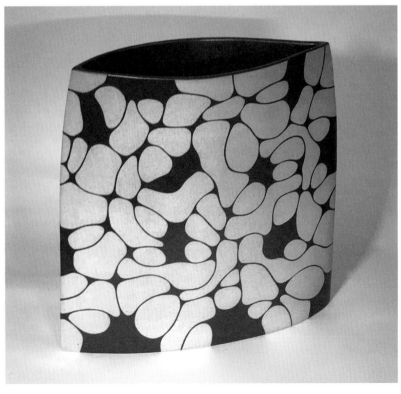

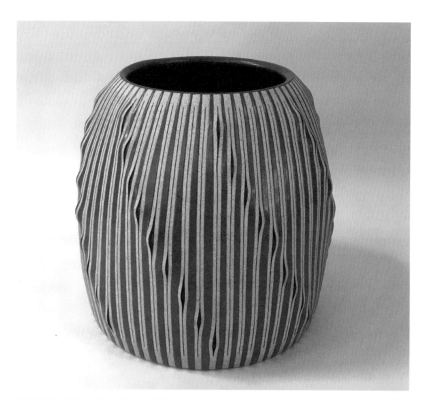

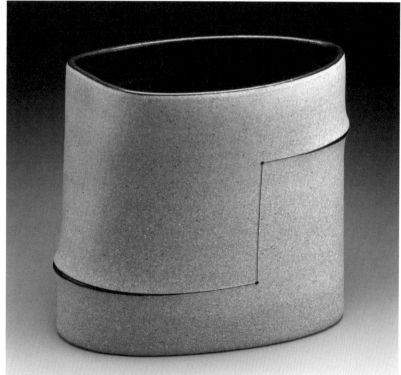

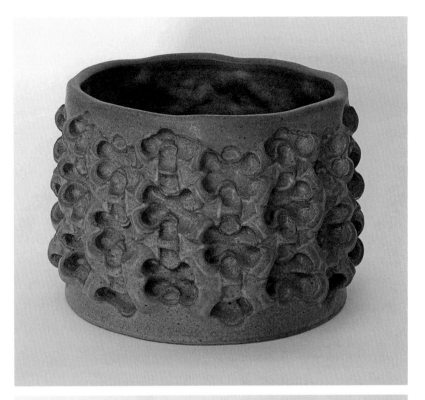

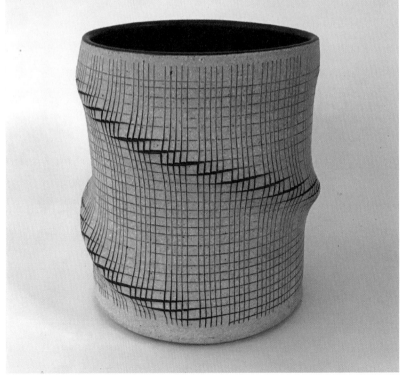

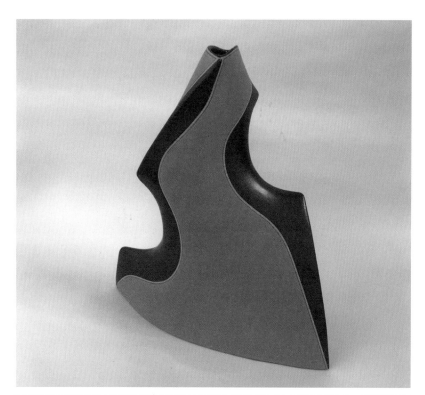

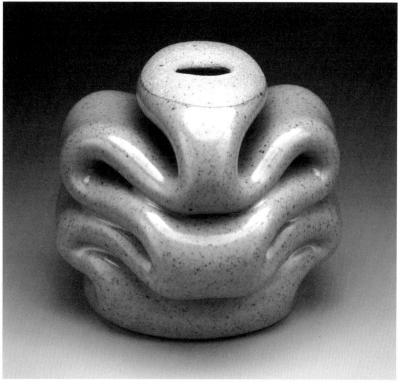

'Creativity must be a natural way of letting the work flow. I don't think there are any general recipes for this. There can't be. It's a personal process impossible to transmit, and each artist has to find this key to ensure their work is genuine and alive. However, I know very well that attention to my craft has helped me a lot; attending to technical demands and observing them carefully is enriching. Creativity is knowing how to be available so that ideas flow, a belief that this will happen by approaching the material. Something always tied to the moment one is experiencing. And for this reason the work evolves and changes, because we ourselves change; it isn't necessary (and it isn't worth it, perhaps it upsets it) to force this process. It's best to arrive at the studio confident that what one is going to do is what corresponds to a concrete moment: here and now.

According to my experience, ideas come in general from my own work, from observing already made pieces, searching for unexplored possibilities in them, qualities that could be developed, alternatives. But the most important thing is to be with the clay, to make something with it. Not necessarily with clarity vis-à-vis what one wants to do. But more with the eyes (and the mind) open to be able to see the possible alternatives of change: very often it's a development but other times it's exactly the opposite. It's necessary to venture off in a new direction: to do something new.

I'm inspired by music, literature, dance. But I think the most important thing for me, the most present is music: from Monteverdi to contemporary composers. And I don't know in what way the influence of what I listen to affects what I do. But at the same time I don't care, for precisely in this inexplicable experience lies the richness of the assimilation of the art we love: it's something unconscious; it has to be.

Drawing is important: a way of learning to think with the hands. For years I filled notebooks with drawings, ideas, which very infrequently were used in clay. Which is to say, they weren't sketches but part of the process as a parallel production in another material.

Another interesting possibility is wandering around the studio in the late afternoon, in a kind of semi darkness that makes it difficult to see the pieces clearly and for this very reason encourages the imagining or glimpsing of things other than ones in front of me, pieces I haven't made but which I could or try to make.'

'You have to work a lot, with your eyes open. And maybe it helps to think the intention shouldn't be to make something important or transcendent, but simply to be a genuine artist, one committed to what they do with passion and seriousness. Not solemnly, because it isn't necessary to think about transcendence or glory; I think enjoying oneself and having fun are more important. Time will tell where to situate what we do, but we shouldn't worry about it.'

'Playing is something that seems to be obligatory for an artist. Knowing these games have rules, and that we have to respect them, even though at the end of the day these rules are subjective, personal, invented by oneself. And also being able to change the rules if we need to. But for me the idea of respecting the rules set for a specific piece works; I can change them for the next one, but not for the piece I'm working on. In this I know I'm very strict.

Making mistakes and accidents are also essential. It can be very useful and instructive, and this is why we must observe very carefully what happens against our will or intention, because many times there's something rich and suggestive there. And of course something new, unexpected and impossible to imagine; hence it's extreme importance. This is why I've made a rule about attentive observation of mistakes and accidents (which always occur, lots of them); before getting rid of what failed you need to study it carefully.'

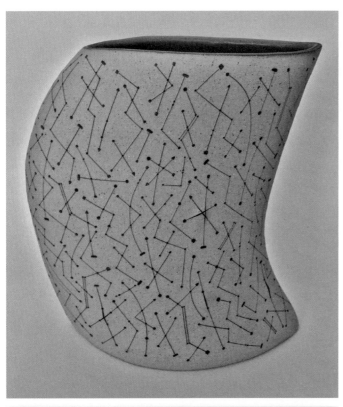

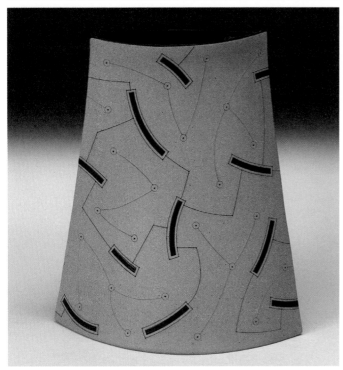

'A useful idea can be paying attention to your own curiosity, learning to listen, to know how to feel what we like to do. And I'm referring to a sensory, tactile, visual pleasure. The specific actions that can be attractive or pleasurable to each person in contact with the clay. For me, for example, I remember, of course, that the possibility of drawing on the surface of a piece with a knife brought me a lot of pleasure, and this happened early, almost when I began to learn at school. I know in that moment I didn't know how to take advantage of this effect; I couldn't use it. It wasn't until some twenty years later that I was able to develop this technique which became characteristic of my work. And this is why I can recommend to anyone who's starting out to pay a lot of attention to what personally gives you the most pleasure when working with clay.

Another thing that seems important to me: the search for a personal language shouldn't be a forced process; one shouldn't work with the idea of "being original". If you're looking for this, you run the serious risk of falling into the trap of being beholden to fashion trends, trying to do something according to what the critical consensus of the moment decides is avant garde. This should be avoided at all costs, trusting instead in that if we heed our personal curiosity, we'll be on the right path towards our own individual way of saying what we want to say.'

'Speaking of secrets, there's an idea that has been with me for years: a secret about creativity is not to keep secrets. And this is because I think the accumulation of technical secrets is a weight, an obstacle, and that having to bear it hinders progress. Being free of this burden is conducive to the emergence of new ideas. That's why I've always shared and explained my techniques with whomever is interested.'

Madhvi Subrahmanian

Photography: Neela Kapadia.

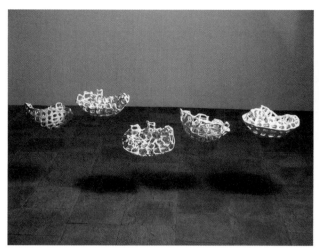

1

2

'I was born in Mumbai, India, into a family that fostered a creative environment and encouraged us in that direction. My mother is a keen gardener with a green thumb and my father built and tinkered with all things mechanical. An atmosphere of finding creative solutions to everyday needs permeated my upbringing and it was no surprise that I naturally gravitated to working with my hands.

Growing up, I have always enjoyed doings things differently and bending norms. While at graduate school in the 90's, most people were making glazed ware at high temperatures, I decided to explore hand-built vessels with exposed fingermarks, fired multiple times at lower temperatures. The multiple firings produced unpredictable results that offered much to learn from.

When motherhood came along, I got a fresh perspective on the ceramic term "clay body" – both physically and metaphorically. I saw my pregnant self, malleable, expanding into a full rounded vessel. I made a mold of my expectant belly in plaster to mark this moment in time. Over the years, I have used this mold to make vessels, sculptures and to develop various installations.'

1. *Belly Pods*, 2008. Fost Gallery, Singapore.
2. *Untitled*, 1993. Meadows Museum of Art, Dallas (USA).

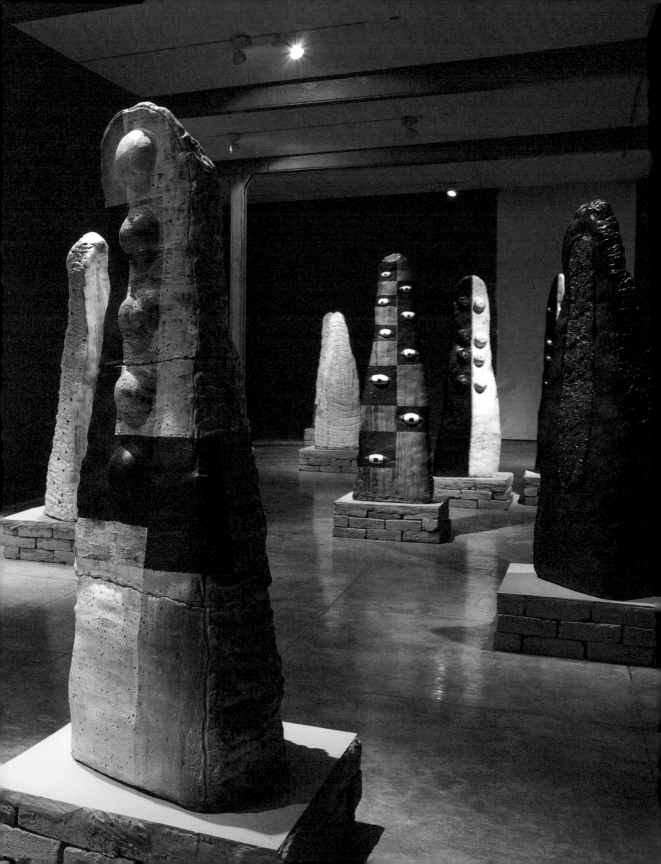

3

'Constantly exploring new directions and taking risks has helped push the boundaries of my material and my practice.'

'My training in the world of clay did not start with the ubiquitous village potter — though I was mesmerised by this Indian institution— but rather at a pottery workshop called Golden Bridge established by an American couple, Ray Meeker and Deborah Smith, in Pondicherry on the Coromandel Coast in South India. Having gained a solid foundation there in material and methods, I found my way to the US for a Master's program in Fine Arts at Meadows School of the Arts, Dallas (USA).

I returned to Pondicherry in 2009, as an artist in residence with a desire to explore larger-than-life forms. The works entitled Seed Pods were hand-built and high fired in a wood-kiln. Moving from the tangible to the intangible, I played with the notion of shape-shifting shadows and explored the displaced perception of the object through its shadow, alluding to temporality and transience, of life and nature. The resulting work Forest of Shadows was shown at the Indian Ceramics Triennale in Jaipur, India and later at The Private Museum, Singapore.'

3. *Seed Pods, Organic/Abstract,* 2010. Chemould Prescott Road, Mumbai (India).
4. *Forest of Shadows,* 2018. Indian Ceramics Triennale, Jaipur (India).

4

Liminal Space, 2020. Upper East Side, New York City (USA).

'Life is full of constraints that push one to find creative solutions. When the inhabitants of New York City (NYC) were confined due to the Covid pandemic in 2020, I was stranded there, having just finished my residency at Hunter College awaiting a flight back to Singapore. I had started the residency photographing road graphics — from zebra crossings to parking boxes — drawing from my previous interests and research (2010) on urban signage in conjunction with the way-side shrines of India. During my exploration in NYC, I noticed that many pavements were filled with chewing gum residue marks. Intrigued, I began investigating the movements of people via the ubiquitous gum marks, documenting them through photographs and drawings.

As the residency ended and Covid struck, my just-opened solo show had to be suddenly abandoned. Dejected in the quietened city, I gathered the courage to consider the city as my studio and the gum-mark filled pavements as my sketch book. Using rice flour and clay, I drew *Kolams* (borrowed from the ritual drawings of South India) daily around the gum marks, thus overlaying a code from my culture onto the urban cultural norm of NYC. I was encouraged by passers-by who perceived many different aspects in these drawings, from constellations to maps. *Kolams* are traditionally patterns made to welcome each new day and are regarded as offerings. My daily drawings on the pavement across from a blood bank and close to a hospital were my tributes and salutations to the essential workers that crossed that path every day.'

Pandemic Pills, 2021. Gillman Barracks, Singapore.

'I am often inspired by exploring things that pique my curiosity. In 2021, I was intrigued by how the pandemic caused by Covid 19 had affected everyone on the planet; never before had the entire world experienced similar emotions at the same time. The constant conversations about the pandemic with people from across the world gave rise to a work entitled *Pandemic Pills*. The work was a participatory installation in which brightly coloured clay pills emulated time capsules that preserved forever the emotions recorded in them. The public were invited to roll each pill in the pillbox on a fine bed of sand. Each twist of the pill slowed the viewer down, inviting them to reflect and connect with a wide range of emotions, from uncertainty and disbelief to happiness and hope, which they may have experienced in those unprecedented times.'

Photography: Indian Heritage Centre Resource Library, Singapore.

Ode to the Unknown, 2017-18. India Heritage Centre, Singapore.

'In 2017, I was asked by a museum in Singapore to "dialogue" with their collection. A seemingly ordinary little glazed cup in the museum's collection caught my eye. I enjoyed researching about the cup and learning about Singapore's history through it. The cups were made by Chinese workers and used to collect rubber by Indian indentured labour in the rubber plantations of South-East Asia in the 1950's. Interestingly, these glazed cups were made and fired in the dragon kiln that occupies centre stage at my studio and today is part of Singapore's heritage. My installation, *Ode to the Unknown,* focused on this small cup as an object of cross-cultural dialogue and labour politics.
I made 1008 polychrome cups and installed them in rings to resemble the rubber plantation. In the installation, the cups framed images (taken from Singapore's historic archives) and brought attention to the nameless, faceless, unknown laborer.'

Ann Van Hoey

Photography: Dries Van den Brande.

"I came to ceramics almost by accident. I was good at maths and sciences, and I got a master's in commercial engineering at Antwerp University. I didn't receive any training in art and design. When I was twenty-four, I went through a difficult period in my life and I felt the need to do something more, to get out of my comfort zone. I enrolled in IKA, the school of art and crafts in Mechelen (Belgium). I was immediately attracted to clay and the atmosphere of the studio. I felt the discipline was one I was well suited for. Then I gave birth to our daughter, so the night classes became more complicated. I didn't take it back up until I was forty-five and when I graduated at fifty, I decided to devote myself entirely to ceramics.

Often people tell me that my pieces fall within the field of design, and in fact what interests me most are forms and lines. Unlike many other ceramicists I'm not inspired at all by nature, nor am I interested in the distorting effects of firing.

Within the field of ceramics I'm a fervent admirer of Alev Siesbye, whose round forms I like, and Tjok Dessauvage for his perfect volumes adorned with geometric lines. Bodil Manz and Piet Stockmans also influenced me a lot when I began, because of their simple, light and very thin forms and their work in unglazed porcelain. American minimalism has also had a big impact on me. Still, it's difficult to explain where my work comes from. I was selected for major biennials because the panel was intrigued by the way I work, my unusual "folding" technique.'

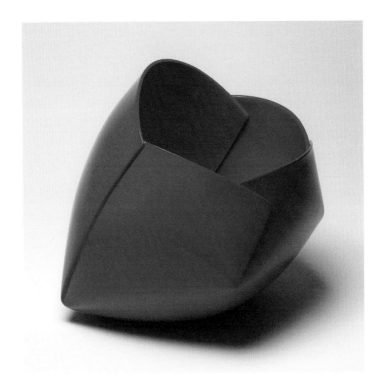

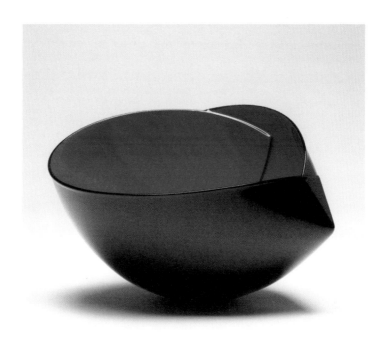

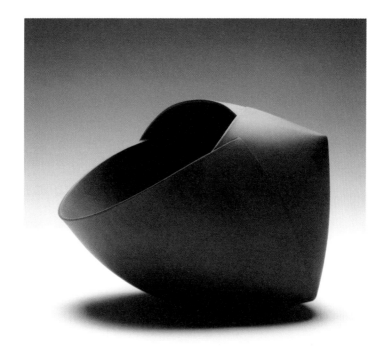

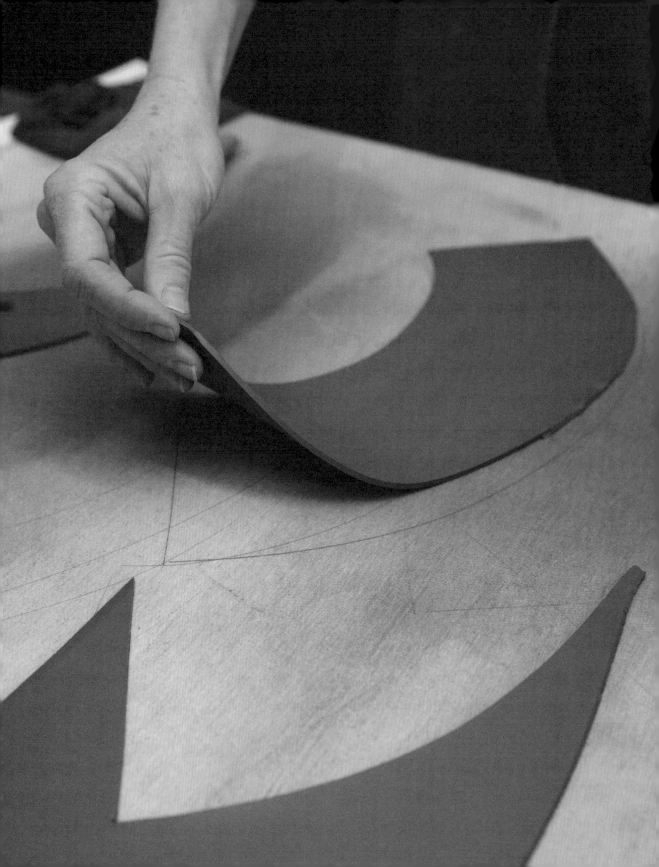

'I like the texture of clay and the formal opportunities it offers.

My objects, since they aren't glazed, can't be used. In general, I don't have the practical side in mind. What really matters to me is the form. For my exhibitions, I strive above all for formal harmony and beauty.

When I began, the objects were monochrome. Their colour, whether dark brown, white or red, was the natural colour of the clay. I think it's my taste for design that has led me to work in colour. But I didn't want any glaze, which would have made the lines of my volumes lose part of their sharpness and precision.

So I thought of industrial lacquering. When using Ferrari red, I liked the idea of a dichotomy between a handcrafted creation and the quintessential symbol of consumption. I don't apply the lacquer myself. It's a complex procedure, since the piece is coloured both on the inside and the outside and the creases in the material make the lacquering extra difficult. One time I went to a studio to lacquer a piece myself, but since then I systematically have a car painter to do it.

For my most recent series of pieces in bright matte colours, I turned to engobe on stoneware. I apply the engobe in several very thin layers in order to have a smooth even effect.

Another aspect of my work is industrial design. For the leading design company Serax, I have developed several lines of tableware. I create the prototypes of each item and Serax takes care of the marketing and the production. My most recent collection 'Nido' was much acclaimed at the major big fairs around the world.'

'There are other formal and technical approaches that I'd like to explore in the future. I have a lot of ideas. Many of them occurred to me while being artist in residence at the Yingge Museum, Taiwan. Until then, I only used very fine clay, but there I experimented with grogged clay, glazes and engobes. There are avenues to explore, with the possibility to add colour, highlighting the lines even more.'

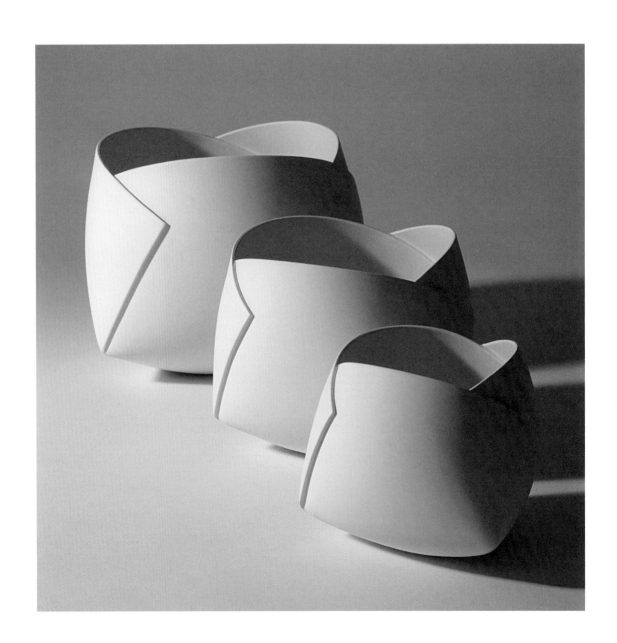

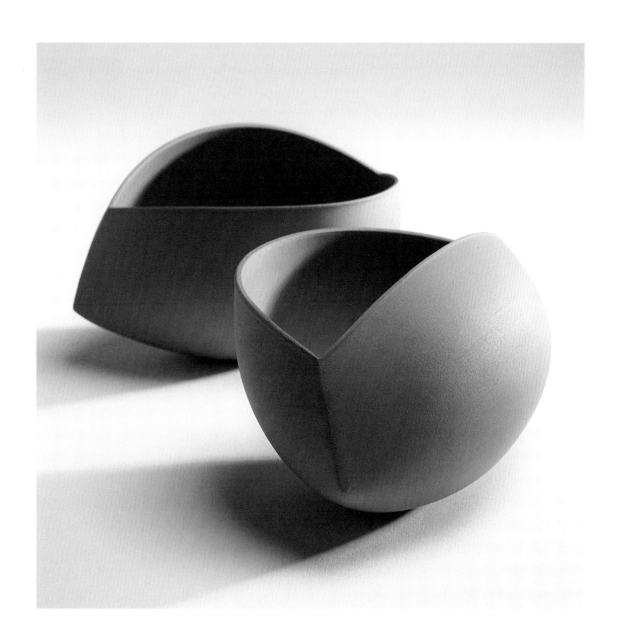

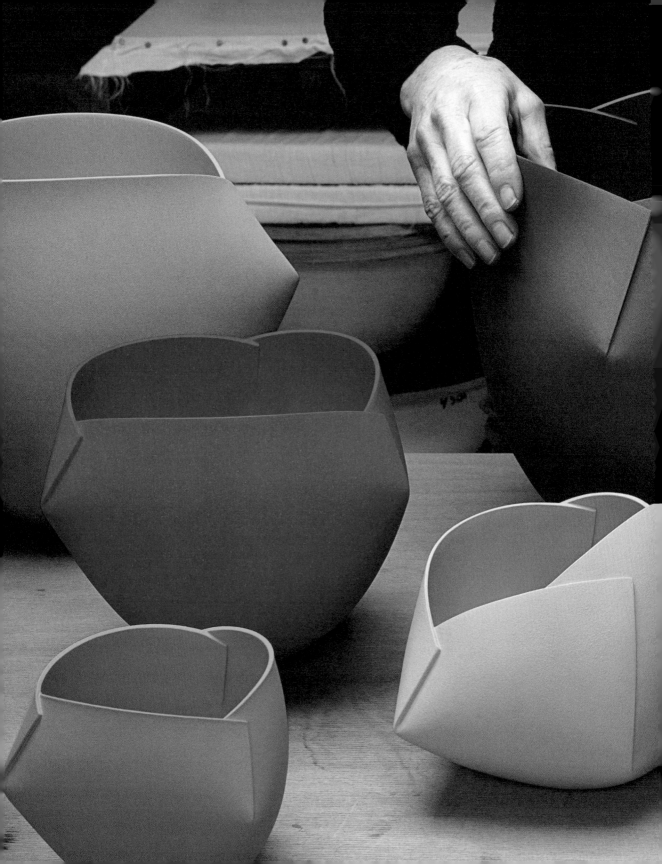

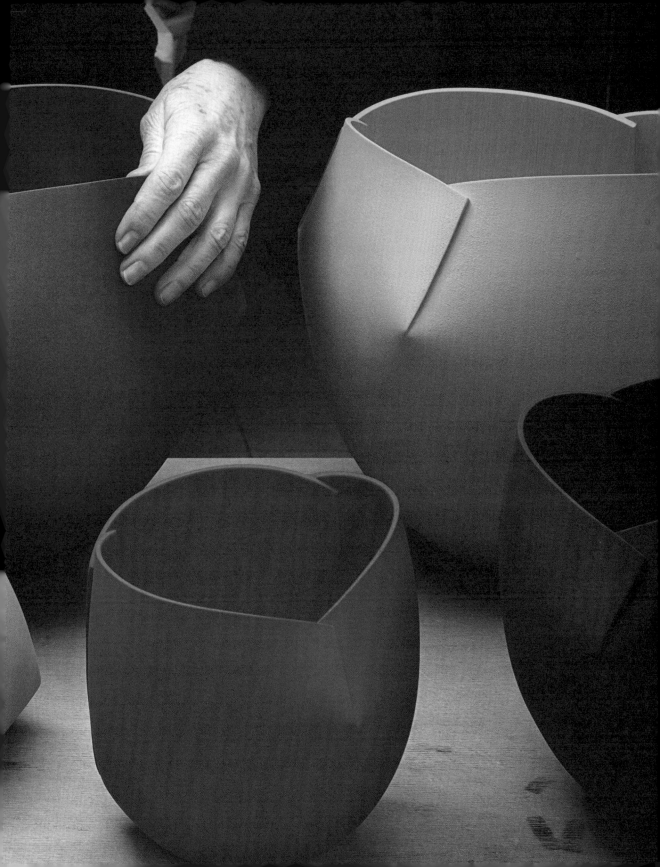

Alice Walton

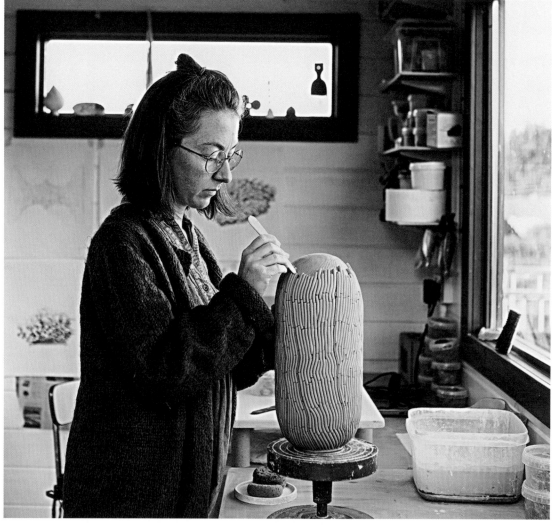

Photography: Megan Gallacher.

1

Photography: Mark Robson.

'I make highly complex and multi-layered porcelain sculptural objects infused with colour pigments to create a rich tonal mixing technique. The labyrinthine texture surfaces cover my sculptures and make it possible to question the material and technique. I explore such themes as travel, place and time through colour, surfaces, layers and drawing.

Participating in residences is an important part of my work. I like to travel and explore new places, and I think that the work I do in direct response to a stay somewhere else tends to be the most successful. When I look back at one of my earlier works, *Linn Ribbons* created in 2019, I'm immediately transported to my Cove Park residence in Scotland. The colours, the land and the sensation of the piece really capture the feeling of the place.'

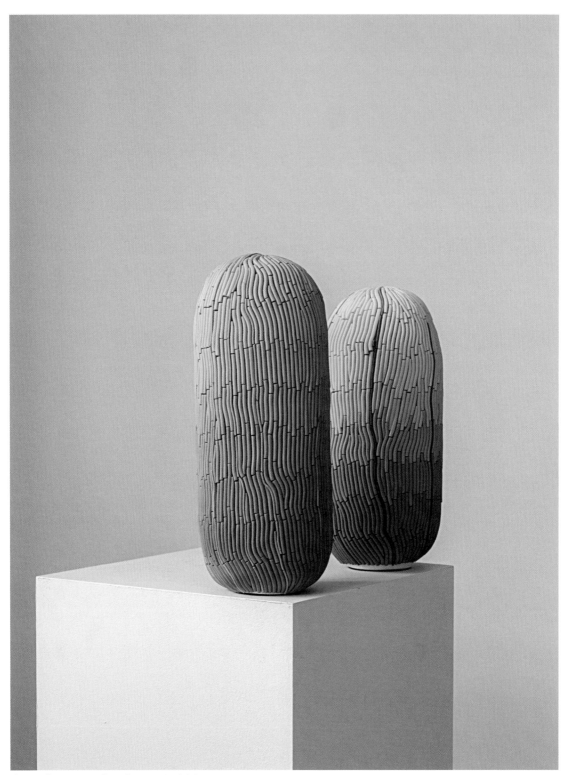

Photography: Dave Watts for Make Hauser & Wirth Somerset.

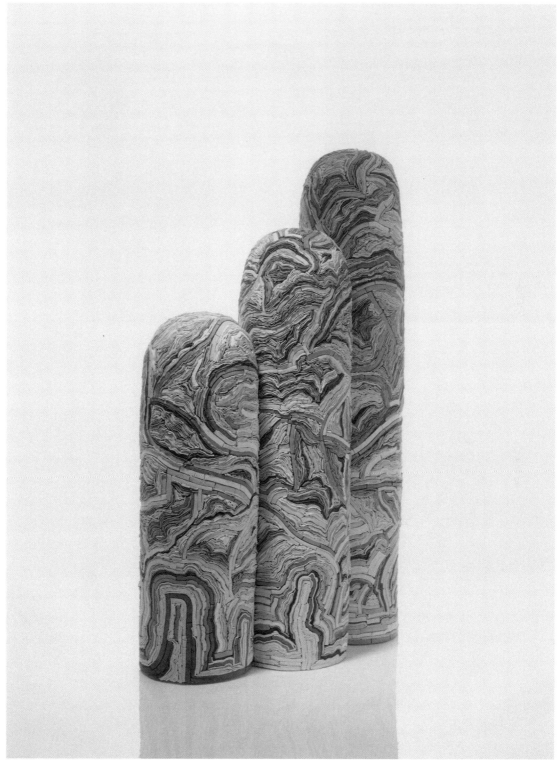

2

Photography: Sylvain Delen.

3

4

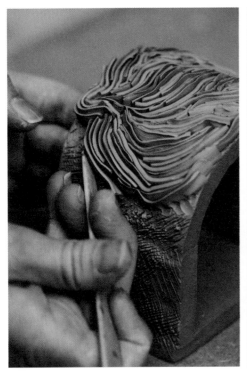

Photography: Asia Werbel.

5

'In recent years, I've taken up gardening, and now my studio opens up onto our pond and garden. I've discovered that, when surrounded by nature, my work begins to be inspired by the changing colours of the season that I see around me. The tones I choose are more natural and mimic the new growth of spring, the autumn textures of the rain, and the sharply defined colours of an icy morning.'

'I'm patient and l love the meditative qualities of my process. I take days, weeks and sometimes even months to decorate my work. I enjoy this detailed and meticulous creation that, in turn, becomes something very personal. I look back and know exactly how I felt and where I was at the time of its creation.'

'One of the reasons why I love working with clay is that each mark that I make, whether a mark made with a tool or a fingerprint, is preserved in the surface of the clay. It's a direct record of the time I've spent with the material, which is very personal. I work on a sculpture while it dries, throughout the entire finishing process. This overlapping of processes creates a personal narrative with the object itself.'

1. *Fosse Ways*, 2022. Porcelain
2. *Janta Grove*, 2019. Porcelain
3. View of the local landscape through the viaduct arch.
4. Autumn colours through my rainy studio window.
5. Collages of paper shapes with coloured porcelain samples in my studio.

'To decide what I'm going to do, I like to travel, whether to explore the area, participate in an artist's residence or go on vacation. I love to walk; I make sure to stop and watch. Once I reach my final destination, I draw from memory. This pause in time allows for abstraction, since I remember and forget certain things. I have a sketchbook that inspires me constantly and where I can look back to. My drawings inspire the forms I make, the colours and the movement of the drawing on the sculpture.'

'I'm inspired by the things I see around me, along with maps, travel, place and the weather. Specifically, I focus on the landscape of the objects that we see around us: bollards, fences, bridges, etc. I like to see how objects change and vary day to day depending on the weather, temperature and human impact.

Since I stopped living in the city, my work has changed. Although I'm still interested in observing my surroundings, I've discovered that I'm more attracted to seeing how nature superimposes itself on objects created by humans and envelops them. For example, the way ivy snakes its way up and coats an old viaduct, or how the lichen covers path markers. I've also realised that now that my studio is in the middle of my garden, the seasons and different plant colours are reflected in the porcelain.'

Photography: Mark Robson.

7

Photography: Asia Werbel.

'I try to separate myself from creating once in a while and return to travelling and drawing. The residences I've done have been incredibly inspiring. The possibility of removing myself from my regular environment and transforming myself in a landscape of new exploration nurtures my work a great deal. Before going to a new place, I make sure I have an idea of the place. I love looking at old maps to familiarise myself with the land and to start to think about how I will move through and explore it.'

'I live in a part of the United Kingdom filled with vibrant industries of the past, old rail lines, Roman roads, viaducts that cross the slopes of hills and tunnels waiting to be explored. Drawing is important in my work, since it allows me to quickly record the ideas that occur to me on a walk. These line drawings are a way of recording a form, colour, texture or surface, ready to be transformed from two dimensions into three-dimensional clay sculptures.

When I start to decorate, I tend to have a rough idea of the appearance that a piece could end up having, but I don't make a definitive plan. I like to allow the form to dictate the movement of the lines that I trace and for the intuitive nature of the material to govern the pattern.

I'd describe my entire training process as a playful period, from when I got an undergraduate degree from the University of Brighton to my post-graduate work at the Royal College of Art. Experimenting is very fun and is a playful way to encounter happy accidents or discoveries through the development of knowledge. This development is crucial to ensure that my work remains fresh and exciting and continues amplifying the material. I still get excited when I open a new kiln.

I try to remember from time to time that clay is an incredible material. You can create anything with it, and the only thing stopping you is your imagination. Doing ceramics is my professional choice and my goal is to build my career throughout my life and to continue enjoying the process of creation.'

6. *Fosse Vale*, 2022. Porcelain
7. Inspired by the colour of the maps. National Library of Scotland.

Wu Wei Cheng

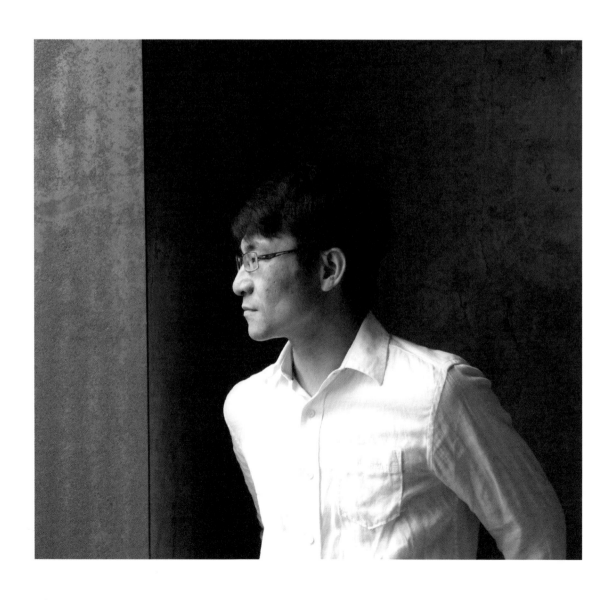

In 1999, Wu Wei Cheng founded his studio, Wu Wei Pottery, which in fact is 'doing something without doing anything', in honour of the natural order of things, which often is referred to as natural law. The craftsman feels comfortable in ceramics and has christened it 'Wu Wei'.

He shares his humility and respect for nature and the sky in the pieces he creates. When shaping them he follows the inherent variations of the material, preserving its natural state, and playing with the linearity of the delicate sense of touch. Wu compares himself to a clay architect interested in all kinds of faces. 'Architecture and pottery have a lot in common. They're both made of clay, which is used to build and situate the content; they have the same philosophy.'

Modern architecture and Western expressionism have exerted a strong influence on his style. He uses flat ceramic panels as components, merging, nesting and transposing them to emphasise the 'layers' of the surface in a penetrating way, superimposing the spatial structure of three-dimensional geometry.

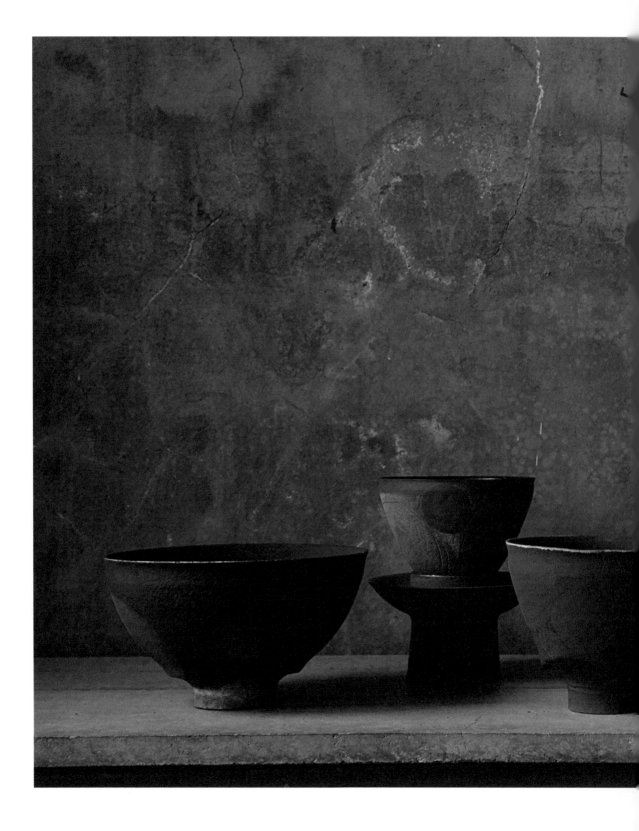

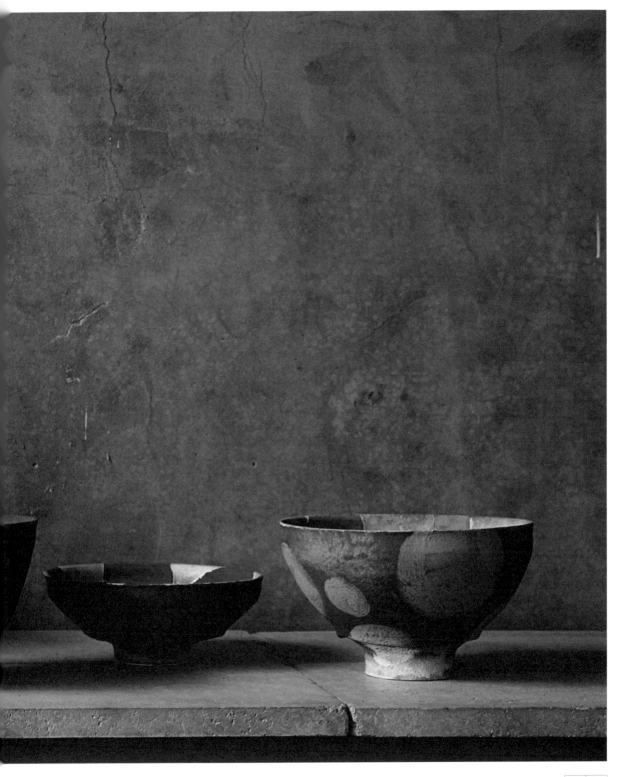

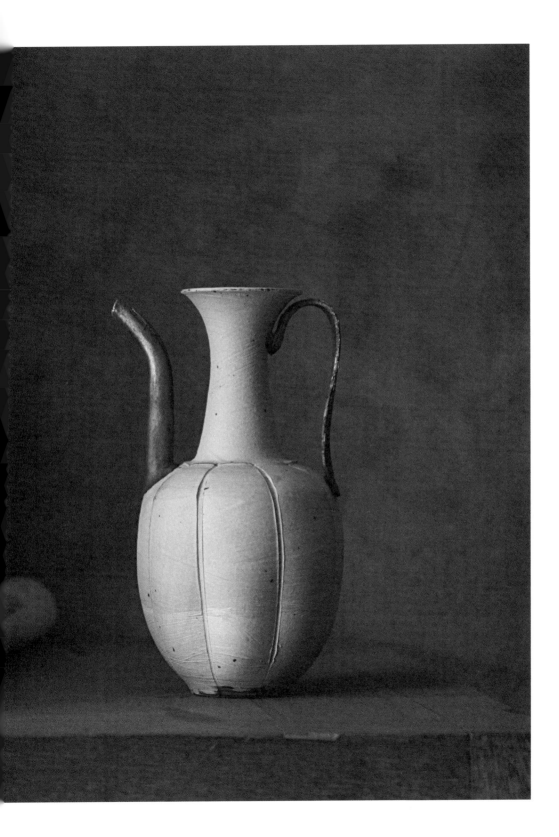

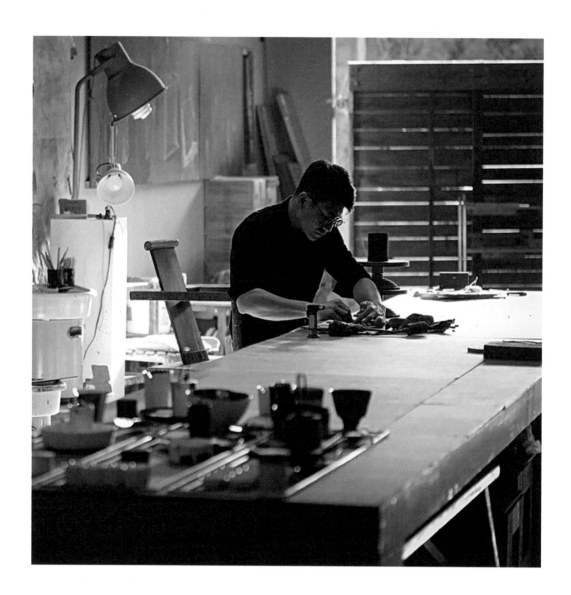

Wu Wei Cheng, who studied pottery at the start of his career, often observed several types of primitive Asian ceramics made of bronze and iron, and he found that the simple forms and decorations without much embellishment possessed the most intriguing beauty, reflecting the pure beauty of nature's power.

He goes back and forth between different media such as painting, calligraphy, lacquer and architecture, combining different artistic forms and techniques to find a state of harmony between them; using oriental aesthetics as a bearer, inheriting the new and inspiring the old, re-exploring and transforming tradition while putting into practice the process of increase and decrease.

The series of tea ceramics creations, *Lack of Ink*, which emphasises the 'earth, fire and work', is a return to the most primitive expression of this mutual ink and fire, underscoring the details of the texture of pieces handmade by firing without glaze.

The composition of clay, the firing method and control over the firing pattern are carefully calculated to highlight the entire effect of the firing, giving the impression of an old wall and mountains, with a soothing yet austere visual impact. The subtle black or grey layers of the minerals create a profound and exuberant movement in his ceramics.

His work combines paper, metal, leather, stone and lacquered objects. He is also capable of moving deftly between craftwork, design and art.

Wu Wei Cheng, who always considered himself basically an architect when he used to serve tea during the tea ceremony, in fact has been drinking tea with this father since he was three years old, and tea has gradually become an integral part of his life.

As a result of his observations and its internalisation, he began returning to Asia in his creations, gradually weakening the masculinity of the pieces and moving towards the beauty of oriental roundness. The shapes and glazes of the tableware are often expressed with humanistic images, expressing a simple atmosphere of subtle elegance.

'I think beautiful tea items must be "unbalanced, simple, wilted, natural, mysterious, unconventional and silent", in keeping with the seventh spirit of the tea ceremony and the aesthetics of the pieces proposed by Japanese Zen and tea master Shinichi Hisamatsu.

While my creations aren't intentional or formal, I preserve this aesthetic awareness as the nucleus of my own tea item creations.'

The tea field is an elegant world which combines tea, water, containers and people. The person who makes the container and the person who drinks the tea are identical and mutual subjects, and the tea container combines these two roles; it has a symbolic meaning, an expectation or an extension of an image.

Modern ceramicists are on the border between tradition and contemporary forces, East and West, the new and the old, and Wu Wei Cheng tries to represent them in his own way, one more in keeping with contemporary aesthetics.

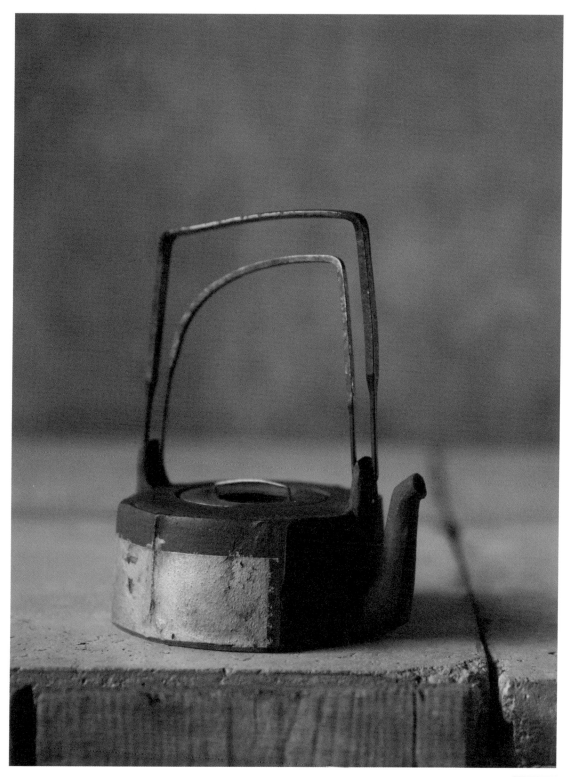

Sophie Woodrow

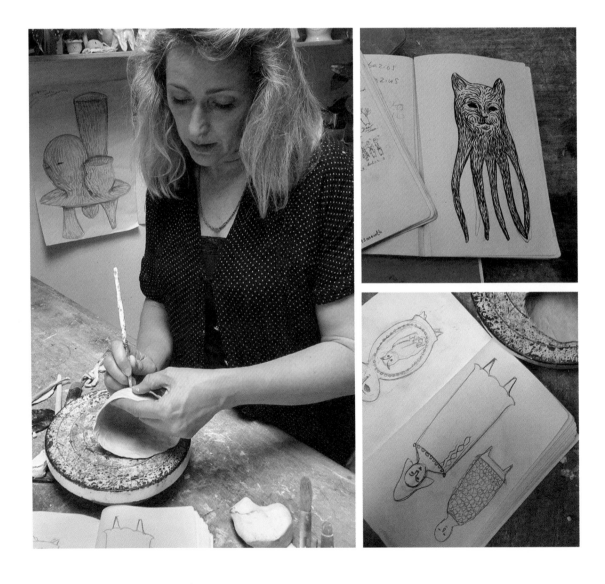

'At university I was attracted to porcelain, for its translucence and the way it captures incredibly fine details, but also strangely, because it's difficult to work with. I like to build by hand, to shape and roll the clay, very simple not overly technical processes. But with porcelain this can be difficult because of the way it behaves; it's very plastic and it's a challenge to obtain a perfect result. I embrace the challenge. I think otherwise my work would seem too finished and less interesting. A lot of people have learned that imposing a limit, or working on a specific assignment, helps them to be creative. My ideas can be very free but the porcelain always imposes a strict requirement on me.

Aside from this, I work very intuitively. The idea for a piece tends to come to me fully formed. I make a quick sketch, which I almost never change. While conceiving the idea is very immediate, the process is slow and measured. I roll the clay upwards, a technique which leaves little room for correction, and if I'm lucky, what I end up with is very similar to the original spontaneous idea.

I make human and animal figures to express my astonishment at the world and to explore my relationship with it. I like to do it by shaping a clay person, something we've done for thousands of years and which I believe will always be important.'

'I'm fascinated by the way people gather and constantly process information. For me these figures are empty. The surface of the clay represents the point of contact with our environment but what's inside is often a mystery, one difficult to define, and for me the best representation is an empty space.'

'Living in a complex world, where the sheer volume of information can be overwhelming and difficult to process, I'm documenting my own personal journey to give meaning to everything. At school I wasn't interested in academic subjects, only the creative ones. But as an adult, and now that I can listen to fascinating podcasts while I work, I'm inspired to learn about biology, environmental sciences, history, psychology, and letting it all converge in my work. I also love going to museums, having so many different objects, from different cultures and periods, in the same space creates such a wonderful energy.

My figures, inevitably, are also a reflection of my sense of self. I think of my figures as psychological portraits. People aren't static. We change as impressions and sensations flow through and around us.'

Photography: Ben Dowden.

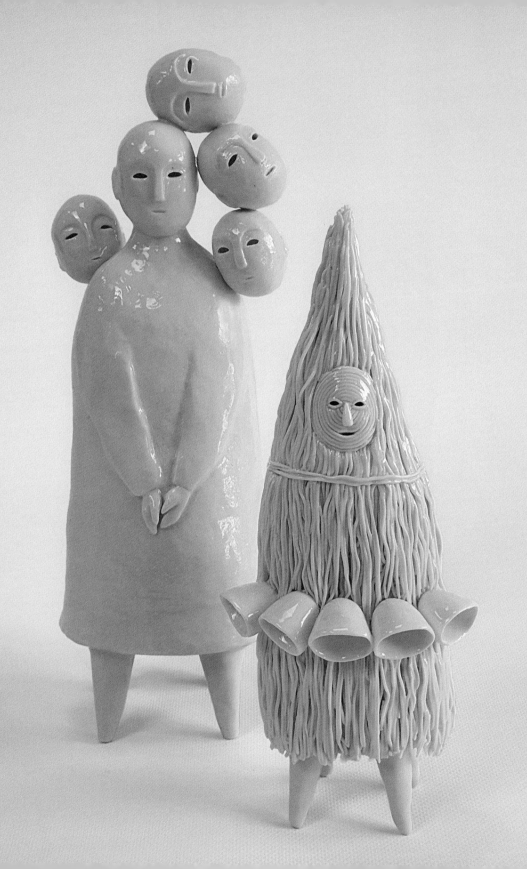

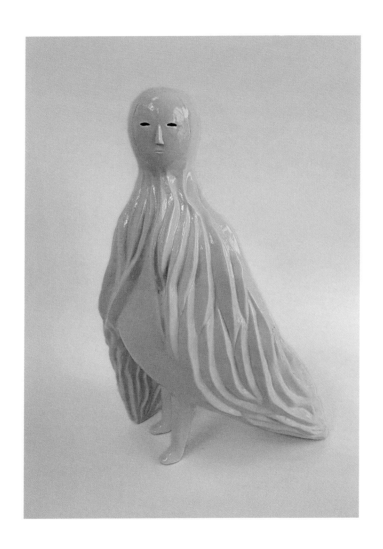

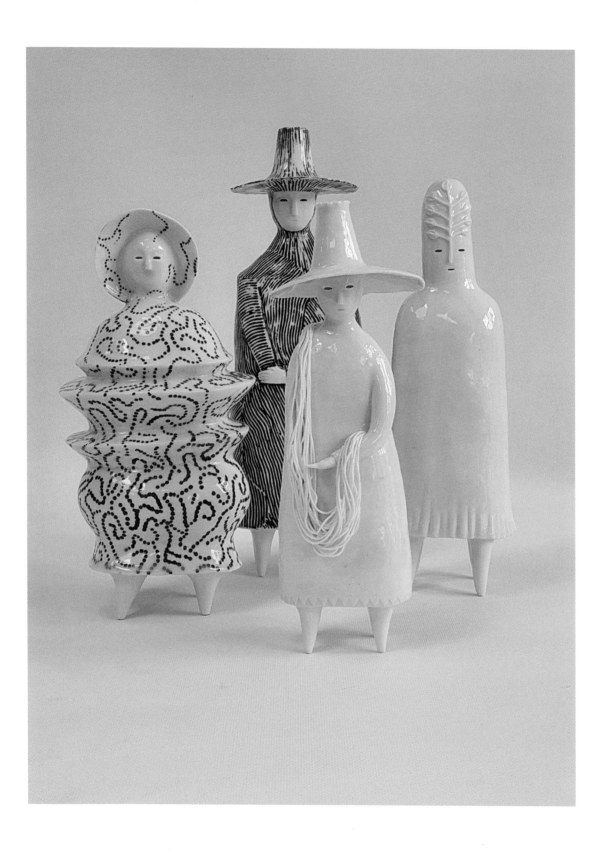

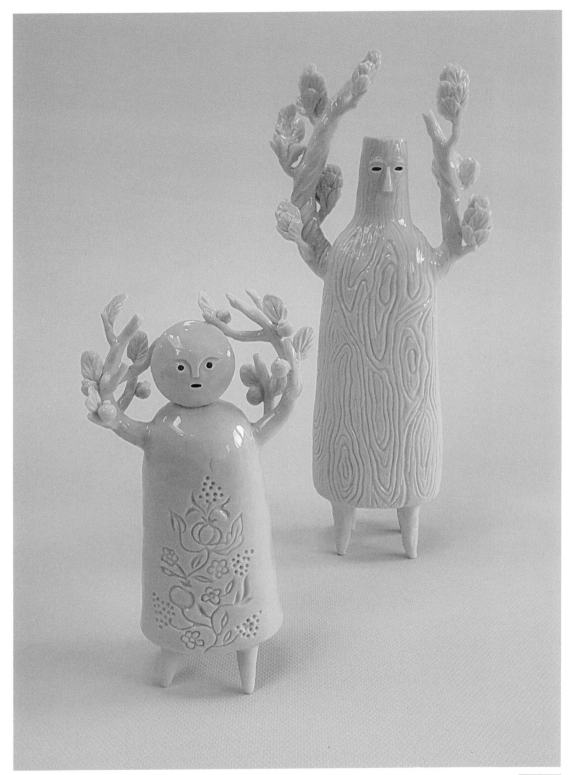

Photography: Ben Dowden.

/

Artists

Monsieur Cailloux
www.monsieurcaillou.com
@monsieur_cailloux_

Roger Coll
www.krasznai.co.uk
@rogercoll_krasznai

Monika Debus
www.monika-debus.de
@debus.ceramics

Godeleine de Rosamel
www.gderosamel.com
@gdesosamel

Nathalie Doyen
www.nathaliedoyen.be
@doyenatalie

Ngozi-Omeje Ezema
ngoziomejea.blogspot.com
@ngozichukwukaomeje

Ana Felipe
www.anafeliperoyo.com
@a_felipe_r

Myriam Jiménez Huertas
@myriam_jimenez_huertas

Cecil Kemperink
www.cecilkemperink.com
@cecilkemperink

Kaori Kurihara
www.kaorikurihara.com
@kaorikurihara.ceramique

Nicholas Lees
www.nicholaslees.com
@nicholas.lees

Wan Liya
@wanliyawly

Ícaro Maiterena
@icaromaiterena

Shozo Michikawa
@shozomichikawa

Xavier Monsalvatje
www.xaviermonsalvatje.com
@monsalvatje

Lauren Nauman
www.laurennauman.com
@lauren.nauman

Yuko Nishikawa
www.yukonishikawa.com
@cyuko_nishikawa

Nuala O'Donovan
www.nualaodonovanartist.com
@nualaodonovan

María Oriza
@mariaoriza7

Paola Paronetto
www.paola-paronetto.com
@paolaparonettocreations

Monika Patuszynska
http://www.patuszynska.art.pl
@monika_patuszynska

Gustavo Pérez
www.gustavoperez.com.mx
@gustavoperez50

Madhvi Subrahmanian
www.madhvisubrahmanian.com
@madhvi.subrahmanian

Ann Van Hoey
www.annvanhoey-ceramics.be
@annvanhoey

Alice Walton
www.alicewaltonceramics.co.uk
@alicewaltonceramics

Wu Wei Cheng
@wu_wei_cheng

Sophie Woodrow
www.sophiewoodrow.co.uk
@sophiewoodrow

/

About the authors

Teresa de la Cal Nicolás

For twenty-three years, Teresa de la Cal Nicolás worked as a graphic designer and an advertising agent. In 2016, she embarked on a year-long journey, during which she became more and more enthusiastic about ceramics: the potter's wheel, wood-fired kilns, glazes, and all the possibilities that unfolded before her. She studied ceramics in different countries (India, Australia, Indonesia, Japan). When she returned to Spain, she swapped her computer for a wheel and an electric kiln and set up her own ceramics studio, Caliche, a quiet place to work on multiple projects that she shares with other creators. In her studio, she organises exhibitions and specialised workshops led by internationally renowned ceramists including Ana Felipe, Marta Armada and Monika Patuszynska.

Teresa has exhibited her work in several group exhibitions: *Gabinete de curiosidades* and *Salvando las distancias* (in Caliche, Zaragoza), *Ciudad cerámica. Ceramistas en la ciudad de Zaragoza*, as part of the activities organised by the International Contemporary Ceramics Fair CERCO (at the Juana Francés Hall, Zaragoza) and *Un bosque de sombras* (at Museo de Albarracín, Teruel).

Miguel Ángel Pérez Arteaga

Miguel Ángel Pérez Arteaga is a graphic designer and also works in advertising communication and illustration. He is the author and illustrator of ten children's books published in Spain, Mexico and Brazil. His books include *How Ideas Are Born: Graphic designers and creative processes* and *Isidro Ferrer: About Nothing,* published by Hoaki Books, and *Creatividad: curiosidad, motivación y juego,* by Prensas de la Universidad de Zaragoza.

He participated in the exhibitions 'Ready to Read: Book design from Spain', a selection of the best books published in Spain, and 'Ilustrísimos: Overview of Children and Young Adults' Illustration in Spain' at the Bologna Children's Book Fair. He has had numerous solo and group exhibitions of his paintings, photography and illustrations.